P9-AGP-728

Comanches in the New West, 1895–1908

Number One
**THE JACK AND DORIS SMOTHERS SERIES
IN TEXAS HISTORY, LIFE, AND CULTURE**

COMANCHES
in the New West,
1895–1908

Historic Photographs

Text by **STANLEY NOYES,**
with the assistance of **DANIEL J. GELO**

Foreword by **LARRY McMURTRY**

Photos by **ALICE SNEARLY** and **LON KELLEY**

UNIVERSITY OF TEXAS PRESS
Austin

Dedicated to

THE COMANCHE PEOPLE

then and now

Requests for permission to reproduce material from this work should be sent to
Permissions, University of Texas Press, P.O. Box 7819, Austin, TX 78713-7819.

∞

The paper used in this publication meets the minimum requirements of
American National Standard for Information Sciences—Permanence of Paper
for Printed Library Materials, ANSI Z39.48-1984.

LIBRARY OF CONGRESS CATALOGING-IN-PUBLICATION DATA

Noyes, Stanley.
Comanches in the new West, 1895–1908 : historic photographs / text by Stanley
Noyes with the assistance of Daniel J. Gelo ; foreword by Larry McMurtry ;
photos by Alice Snearly and Lon Kelley. — 1st ed.
p. cm. — (The Jack and Doris Smothers series in
Texas history, life, and culture ; no. 1)
Includes bibliographical references.
ISBN 0-292-75568-6 (cl : alk. paper)
1. Comanche Indians—Pictorial works. 2. Comanche Indians—History.
I. Gelo, Daniel J., 1957– . II. Title. III. Series.
E99.C85N68 1999
978'.0049745—dc21 98-22004

Publication of this work was made possible in part by support from the
J. E. Smothers, Sr., Memorial Foundation and the National Endowment
for the Humanities, an independent federal agency.

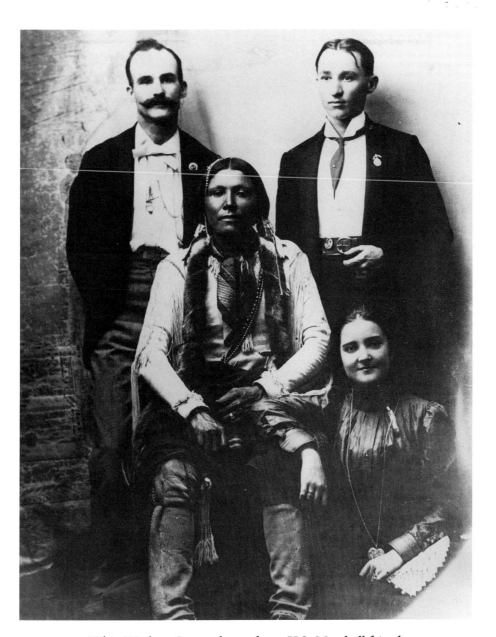

*Tobin Worksu, Comanche, and two U.S. Marshall friends
with unidentified young lady, circa 1900.*
Courtesy Fort Sill Museum, Fort Sill, Oklahoma.

Contents

Foreword

My interest in these photographs, here so elegantly presented and so authoritatively introduced, began in the mid-1980s, when I was given a print of Photo 30—the demonstration of the kerosene lamp—as a Christmas present by two Yankee carpenters, Woodbridge Fuller and Frances Renaud, who were enduring a period of painful exile in Texas while they fixed up my big prairie-style house. Woody and Fran now and then escaped the rigors of life in Archer City, a very un-Vermont-like place, by ranging far to the antique marts of the prairies.

For this wonderful, eloquent photograph, though, they only had to go twenty miles, to the den, as it were, of Dale Terry, the trader mentioned in Stanley Noyes's acknowledgments. At the time I thought the bare-headed Indian wearing the white neckerchief was Quanah Parker (he is now revealed to be Potiyee, a Kiowa), but that is not why I loved the picture. To me it was and is an exciting photograph, both aesthetically and historically. Here is a crowd scene in which every member of the crowd, whether cowboy, soldier, or Indian, is seen distinctly. It captures not just a moment but a society, the society that existed on the southern Oklahoma plains at the century's beginning.

Also, it captures a moment of profound change: light of a new kind comes to the prairie, the place of light. When I saw it I thought immediately of an afternoon in 1941 when I watched workers setting the poles that would bring electricity to our ranch house. By then the new light shown in Photo 30 had had its day, a day that lasted forty years.

A few months after I was given Photo 30 as a Christmas present, Dale Terry sold me the remainder of the glass negatives, which included photographs of Quanah Parker and Geronimo as well. I had just read Angie Debo's fine biography of Geronimo and was interested to see the old man posing for the photographs that he learned to sign and sell.

Looking at any photograph made in a time long past is, in a way, to look at ghosts, but looking at glass negatives accentuates the sense of the subjects' ghostliness. With the images undeveloped, unprinted, the subjects do indeed seem to have sent

back only their shadows. Crazy Horse, the Oglala warrior, seems to have successfully avoided photographers during his four months of semicaptivity; he didn't particularly like the thought that those not yet born might make use of his shadow, as they surely would have had he left it.

These photographs are eloquent testimony to the work of Alice Snearly and Lon Kelley, work that is patient, scrupulous, tactful, and discriminating. The photographers caught the shadow of the world that interested them, and just in time. For that, we can all be grateful.

LARRY McMURTRY

Acknowledgments

I wish to express my gratitude to the many people who have helped me in the research and composition of this book. First—and most of all—I thank Daniel J. Gelo, my "silent partner" in this enterprise. Besides providing ethnographic details for the captions, Dan read everything I wrote, more than once, making valuable suggestions and, through his knowledge as an anthropologist, spotting potential blunders on my part. I could not have written the text in its present form without his help. Second, I thank Sam E. DeVenney, who, as the saying goes, learned the Comanche language at his grandmother's knee. Sam, an enrolled tribal member, knows Comanche genealogy and possesses an extensive collection of historic photographs. I owe the identification of nearly all the Indian subjects of the historic photographs in this book to Sam's willingness to help me and to his patience in putting up with my many questions. He succeeded in satisfying my doubts even when there were previous divergent identifications.

I'm also grateful to Towana Spivey, Director of the Fort Sill Museum. Throughout my visits to Lawton and Fort Sill, Oklahoma, Towana was exceptionally helpful, sending me information and on several occasions taking time from a killing schedule to grant me interviews. He was also the source for many details concerning photography during the 1890s and beyond. I especially appreciate his arranging for me to peruse the Ben Fish Collection in the museum's photography archives, as well as for permitting the University of Texas Press to use a print from that collection as the jacket photo.

I owe thanks to Philip Narcomey, who introduced me to Sam DeVenney at the Comanche Nation Fair at Fort Sill in the fall of 1995, as well as to Phil's wife, Gladys, a tribal member who, through helpful remarks during three fairs and through her correspondence, provided me with useful information and corrected some of my mistaken impressions. Other members of the Comanche community who assisted at one time or another are Margaret Thomas, a valued older friend of Dan Gelo's, and Barbara and Kenneth Goodin. Thanks, too, to Ozzie Red Elk, who

allowed me to look through the tribal collection of historic photographs (mostly from the Smithsonian) in his office at Medicine Park, Oklahoma.

Dale Terry, of Wichita Falls, Texas, previous owner of the glass plate negative collection that is the basis for this book, also deserves thanks for his help in identifications and for providing other useful data. Louise Womack, of Henrietta, Texas, a member of the Clay County Historical Society, identified her uncle, Harrison Schwend, for me and provided other badly needed assistance on several occasions. Eugene W. Hurn, formerly of Henrietta and presently residing in Wichita Falls, sent me copies of relevant historic photos. Professor Hurn, himself the author of two collections of Clay County, Texas, photographs, provided helpful background information concerning the Snearly and Kelley families and gave me a sense of life in Henrietta around the turn of the century.

Thanks are due Brian Smith, Photo Archivist at the Museum of the Great Plains in Lawton, Oklahoma, who, in conjunction with Sam DeVenney, offered a brief review of a selection of images from the museum's collection. In addition, I thank him for referring me to the Oklahoma Historical Society in Oklahoma City. I am greatly indebted to Chester Cowen, Photography Archivist of that organization, for invaluable information concerning the photographers Lon Kelley and Alice Snearly and their sojourn in Duncan, Oklahoma, from around the mid-1890s to about 1901. Mr. Cowen solved what had been for me a mystery as to the whereabouts of the two photographers at the time when Alice is believed to have shot most of the pictures used in this book. For that I'm grateful.

In addition, I wish to thank Betty Sena, librarian in the Southwest Room of the New Mexico State Library, for her assistance on at least one occasion this year. I also appreciate the help I received from Betty L. Bustos, assistant archivist and librarian at the Panhandle Plains Historical Museum, Canyon, Texas, and to the librarians at the Clay County Public Library in Henrietta. I'm grateful to Dumont Maps and Books of the West, of Santa Fe, for permitting me, on a couple of occasions, briefly to use their shop as a research library. My friend Noreen Moon, a landscape architect in Santa Fe, helped me with remarks on the painted canvas backdrop used in the studio photos. I would like, furthermore, to acknowledge, besides Dan Gelo, the Comanche scholars whose research and writing provided valuable information for my historical introduction, namely, Morris W. Foster and, especially, William T. Hagan, whose *United States–Comanche Relations* I recommend to anyone wishing to investigate further the Comanche reservation period. Finally, my heartfelt thanks go to my friend James Schevill, poet and playwright, who read the manuscripts of the introduction and the note on photography and made valuable suggestions, as he invariably has done with the manuscripts of all my books over the years.

To all those mentioned above, once again, a sincere "Thank you!"—or, in Comanche, "Ahó!"

Comanches in the New West, 1895–1908

Historical Introduction

ONE

On the morning of October 19, 1867, at a clearing among elms near Medicine Lodge Creek, Kansas, a "grand council" was preparing. The participants were chiefs of the Comanche, Kiowa, and Arapaho nations, along with a single Cheyenne, Grayhead, whose people were yet to arrive. These chiefs sat on logs facing the United States Indian Peace Commissioners, themselves seated in chairs arranged in a semicircle. Behind the officials, members of the press sat at tables. A few branches, forming an arbor, partially shielded the commissioners and reporters from the sun, splitting its beams so that sunlight and shadow fell in chiaroscuro among them. At a distance behind the chiefs stood their ponies, most likely pinto geldings or stallions, flicking flies or cropping the grass. At 10:00 A.M. the Kiowa crier opened the council by loudly admonishing the assembled chiefs to—above all—"do right."

One of the reporters at a table was a Britisher named Henry M. Stanley, later famous for adventures in Africa, where he located the missing Dr. David Livingstone. Now, at the grand council, he practiced his descriptive skills by noting such details as the "crimson petticoat," black cloak, and "small coquettish velvet hat decorated with a white ostrich feather" worn by a Mrs. Virginia Adams, interpreter for the Arapahos. Mrs. Adams, he recorded, was equally fluent in the Kiowa language. Appropriately, near her, in front of the other chiefs and proudly seated on a camp chair, was the "redoubtable" Kiowa leader, Satanta. Stanley had described him that April at Fort Larned, Kansas, as a man with "a much painted and vermillionish face," wearing a U.S. Army "captain's regulation coat, with epaulettes to match" and leggings with little brass bells. Seated modestly behind Satanta on a log with the other chiefs was the old and bespectacled Yamparika Comanche divisional chief, Ten Bears.

But the old chief was not overawed by the powerfully built warrior seated before him: "What I say is law for the Comanches," he had snapped at a meeting the previous day, when annoyed at his allies. "But it takes a half dozen to speak for the Kiowas."

Still, on this day, when Satanta addressed the peace commissioners and when

Ten Bears, the following day, spoke to the same officials, the purport of the two speeches was similar. But first—introduced as "a great peace man"— Senator John B. Henderson opened the council. The senator began by reproaching the assembled chiefs for violations of a treaty concluded two years previously at the mouth of the Little Arkansas River. For instance, he accused, it had been reported that they had attacked "peaceable" work crews building railroads, and had scalped women and children.

Nevertheless, he pledged, the government for which he spoke intended "to do justice to the Red Man." He was happy, he said, to see the tribes so disposed toward peace. In enthusiastic phrases he described how he and the power he represented wished to bestow upon them "all the comforts of civilization, religion, and wealth." These included "comfortable homes upon our richest agricultural lands." Moreover, the government was prepared to provide them with teachers, schoolhouses, and churches, as well as agricultural implements and livestock. He concluded by informing the chiefs that after hearing what they wished to say, "we will tell you the road to go."

After rubbing his palms with sand and shaking hands around, Satanta responded, standing in the center of the circle. He first pointed out that the Kiowas and Comanches had kept the peace since signing the treaty two years before. It was the Cheyennes who had been fighting "in broad daylight so that all could see them." After this opening, he quickly reached the heart of his oration, declaring flatly that "all of the land south of the Arkansas belongs to the Kiowas and Comanches," and that he didn't want to part with any of it. Furthermore, he didn't want any medicine homes [churches] built in his country and he wanted the tribal children raised just as he had been. As he continued, he made conventional compliments to the members of the commission, who were all "big chiefs." But a candid strain of mistrust also emerged in remarks such as "I have no little lies hid about me, but I don't know how it is with the commissioners; are they as clear [transparent?] as I am?" At the end of his speech, he sat down, drawing a crimson blanket around him. The response on the part of the commissioners, to the degree that Henry Stanley could see them from his table, was a unanimous "blank look."

The next morning Ten Bears, after donning his spectacles, delivered his well-known address, beginning diplomatically with conciliatory and flattering remarks directed toward the commissioners. But he soon referred to past skirmishes with the "blue-dressed soldiers," conflicts always initiated by the Americans, he claimed. He progressed to war with the Texans, during which the Comanches had held their own. "The Comanches are not weak and blind," he said, "like the pups of a dog when seven sleeps old. They are strong and far-sighted like grown horses. We took their [the Texans'] road and we went on it. The white women cried and our women laughed."

He then made his key point, complaining that "there are things which you have said to me which I do not like." Referring to the Peace Commission's intention of placing his people upon a reservation, of building them houses and churches, he declared, "I do not want them. I was born upon the prairie," he said, "where the wind blew free and there was nothing to break the light of the sun. . . . I want to die there and not within walls. I know every stream and every wood between the Rio Grande and the Arkansas. I have hunted and lived over that country. I live like my fathers before me and like them I live happily."

Ten Bears then referred to his trip to Washington, taken some time before, and to a promise made him there: "When I was at Washington the Great Father told me that all the Comanche land was ours, and that no one should hinder us from living upon it. So why do you ask us to leave the rivers, and the sun, and the wind, and live in houses? Do not ask us to give up the buffalo for the sheep." Returning to his people's war with the Texans, whom the Comanches had never really accepted as Americans, he lamented their intrusion into his country, saying there might otherwise have been peace. But the reservation the government was asking the tribe to live on was too small. No, it was too late. "The whites have the country which we loved, and we only wish to wander on the prairie until we die."

The old chief's speech was eloquent and moving, a classic of American oratory. Even the commissioners might have been willing to grant that. Nevertheless, it was Senator Henderson, in his reply to the assembled tribal leaders, who had the last word. In today's popular phrase, he made the tribes "an offer they could not refuse."

The senator began by promising the Comanches and Kiowas that the government was prepared to stand by a central condition of the earlier treaty: that they might continue "to hunt up to the Arkansas River." However, he warned these southern chiefs that "the buffalo will not last forever" and that the bison "are now becoming few . . ." A day was coming when "the Indian must change the road his father trod, or he must suffer, and probably die. . . . The whites are settling up all the good lands. They have come to the Arkansas River. When they come, they drive out the buffalo. If you oppose them, war must come. They are many, and you are few. You may kill some of them, but others will come and take their places. And finally, many of the Red Men will have been killed, and the rest will have no homes. We are your best friends, and now, before all the good lands are taken by whites, we wish to set aside a part of them for your exclusive home. . . . We propose to make that home on the Red River and around the Wichita Mountains, and we have prepared papers for that purpose. Tomorrow morning, at nine o'clock, we want your chiefs and headmen to meet us at our camp and sign the papers."

In the end the Comanche and Kiowa leaders scratched their X's on the treaty, thus setting out on the "good road" offered by the Peace Commission—and this in spite of misgivings almost surely felt by all the Indians and forthrightly expressed

by the skeptical Satanta during his speech two days previously—"I hear a good deal of fine talk from these gentlemen, but they never do what they say."

After the signing, the commissioners ordered the distribution of the promised annuities and presents, which had probably attracted most of the Indians to the Grand Council in the first place. According to Henry M. Stanley, these included more than $150,000 worth of provisions for the tribes, in addition to "two thousand suits of uniform, two thousand blankets," boxes of tobacco, bolts of various kinds of cloth, a few "squaw axes" and navy revolvers, as well as thread and needles, beads, brass bells, butcher knives, little mirrors, and "sixteen silver medals." The Comanches' and Kiowas' share was a meager price for what they had rendered in exchange to the U.S. government, although the chiefs who signed may not have understood entirely that they and their people would eventually be expected—and compelled—to conform strictly to the treaty's conditions. Nor, for that matter, were they perhaps fully aware of the magnitude of their loss through the agreement if it were to be strictly enforced.

By the treaty's terms the Comanches and Kiowas were forbidden either to attack work crews constructing railroads through their country or to harass settlers. They were obligated to permit the building of roads and military posts. Their vast "home" was to have an agency, along with the schools they did not want, and a doctor. The government also optimistically committed itself to supplying them with farm implements, seeds, and guidance on farming. While the treaty contained a promise of annuity goods for thirty years, these were to be distributed from time to time as the government should see fit.

Although the Comanches, Kiowas, and Kiowa-Apaches were free to hunt below the Arkansas as long as the game lasted, they had agreed, in principle—though probably only the chiefs dimly realized it—to remain at other times confined upon their new reservation of some 5,500 square miles. Of course, by the treaty signed two years earlier on the Little Arkansas, the Comanches and Kiowas had already agreed to accept a reservation of 6,200 square miles, much of it in Texas. United States Indian Commissioners had supervised the distribution of presents, and the reservation clause had been ignored and probably forgotten by the tribes.

No doubt Comanche leaders looked forward to a similar outcome on this occasion. But by signing the Medicine Lodge Treaty the Comanches and Kiowas had a second time relinquished their claim to most of their territory, reaching historically from the Arkansas River in the north to the Balcones Escarpment, a little above San Antonio, in the south; and from the Pecos River and the Sangre de Cristo range in the west to a little beyond the 98th meridian in the east. It was the enormous expanse the Spaniards had called "comanchería."

The validity of the treaty was dubious in any event, even if the signing chiefs had fully understood the implications of all its provisions. A mere hundred lodges

of Comanches, Nʉmʉnʉʉ or Nuhmuhnuh, as the People called themselves, had been present. The Yamparikas, or Eaters of the Yap Root, had signed; the Penatekas, or Honey Eaters, had signed; the Nokonis, or Wanderers, had signed; but at least two other divisions—the Kotsotekas, or Buffalo Eaters, and the Kwahadas, or Antelopes—had not been present at the council and had therefore not been represented. Yet Washington, and the Peace Commission, had intended the treaty to obligate the entire tribe. Eventually it did, but only through the government's recourse to "the blue-dressed soldiers."

TWO

From the first, the U.S. government was dilatory in meeting its Medicine Lodge Treaty commitments to the tribes, particularly regarding provision of food. Those Indians who actually set up their tepees on the reservation behaved in an independent and unruly fashion, especially when hungry. Those not upon the reservation pursued their nomadic lives, following the buffalo and hunting as always. Because of the Comanches' warrior ethos and because the People had never become convinced that their old enemies the Texans were really Americans and therefore parties to the treaty, young warriors, seeking prestige, loot, captives, and horses, soon began raiding again. Then, in the eight years following Medicine Lodge, several events occurred that ultimately compelled the Comanches to limit their roving to the new "home" that Congress had designated for them.

The first of these events, which occurred in the spring of 1873, was the appearance among the Comanches of a prophet. This person was a young warrior named Isatai. (His name has traditionally been rendered as "Coyote Droppings"; the ethnohistorian Thomas W. Kavanaugh translates the name more accurately as "Wolf's Vulva.") After acquiring a reputation for miraculous feats—such as swallowing and spitting out a stock of cartridges—and successful predictions—for instance, that a comet would disappear on a certain date and be followed by drought—Isatai gained numerous followers among his own people and among some Kiowas, Arapahos, and Cheyennes as well.

The prophet's central message, which emphasized the necessity of a war of extermination to be fought against the whites, reached a mostly receptive audience. The year after his appearance, during a time of hunger on the reservation, Isatai decreed a tribal sun dance. The call came at a period of such anxiety among the People, owing to the increasing scarcity of bison as well as to the other pressures upon them, that all of the divisions, both on and off the reservation, attended.

The dance created a sense of solidarity and fostered a warlike fervor among the gathered Comanches as well as among Isatai's followers from other tribes. As a

result, on the morning of June 27, 1874, an array of mounted warriors—Comanches, Kiowas, Cheyennes, and Arapahoes—charged a fortified buffalo hunters' outpost known as Adobe Walls in the Texas Panhandle, about a mile from the abandoned Bent trading post (established by Charles and William Bent of Bent's Fort). The hunters happened to be awake and supplied with heavy, long-range rifles. They repelled the first charge and successive ones throughout the morning. In all, the great war party killed three Anglos while losing nine warriors, with numerous others wounded. Finally, accepting failure after a painful demonstration of Isatai's powerlessness, the throng of horsemen rode away, only to split into groups and rampage elsewhere, raiding and murdering whites wherever they could find them in Texas, New Mexico, Kansas, and Colorado.

The outbreak ended Washington's 1870s peace policy toward the tribes. The army was ordered to force the Indians back to their reservation, an order that resulted in the Red River War of 1874. In that campaign, troops under various commanders rode into the Comanche-Kiowa country from the four directions, one of them marching up the Red River. Although the two sides fought no great battles, the Indians suffered crippling losses in supplies and horses captured. Their greatest reverse resulted from Colonel Ranald Mackenzie's surprise attack upon a great encampment in Palo Duro Canyon. In this engagement, the colonel's cavalry drove Comanche warriors, who fought a rear-guard defense, and all the camp's population from the canyon, then burned their tepees and winter supplies and seized over fourteen hundred of their ponies, most of which Mackenzie ordered shot in nearby Tule Canyon to prevent them from falling again into Comanche hands.

That winter, with few ponies or supplies, many Comanche families suffered severely, and one by one entire bands of the People limped in to Fort Sill to surrender. In February 1875, 250 more cold and hungry men, women, and children came in. Finally, the last intact band of Comanches, the Kwahadas, led by chief and prophet Isatai and by Quanah Parker—son of Cynthia Ann, a captive Texas woman, and a Comanche chief—surrendered to Colonel Ranald Mackenzie at Fort Sill in June.

The first tribal enrollment taken at the agency that August listed just 1,597 Comanche individuals, with perhaps another 50 still resisting surrender—a revealing tribal total for a people who, according to the eighteenth-century French trader and Spanish officer Athanase de Mézières, had once reckoned their number by "comparing it to that of the stars."

THREE

The Southern Plains were at last safe for white settlement. During the years immediately before and after the signing of the Medicine Lodge Treaty, the Comanches

and their Kiowa and Kiowa-Apache allies had lived in ever more precarious circumstances. Yet, though in danger themselves, they had made their territory even more dangerous for would-be white settlers. In the classic anthropological account *The Comanches: Lords of the South Plains*, the authors, Ernest Wallace and E. Adamson Hoebel, estimate that Anglo settlements advanced farther in the ten years following 1874 than they had during the previous fifty years. Hugely outnumbered as they were, the Comanches and their allies had made the Southern Plains perilous for intruders. Now, in increasing numbers settlers swarmed in, seeking the best land on which to farm or ranch and on which to build their homes.

Previously, however, a few cattlemen had taken the risk of entering Comanche territory, a risk that, for those ranchers who survived, was soon to place them in an ironic symbiotic relationship with the Comanches. In 1866, Charles Goodnight and Oliver Loving had driven a herd of longhorns west from Fort Belknap, Texas, by way of Horsehead Crossing on the Pecos to Fort Sumner, New Mexico, and from there northward, following the river and hugging the mountains, to the South Platte, beyond Denver. The following year, on a similar drive, Loving paid for his daring with his life, killed by Indians, probably Comanches. Goodnight also trailed John Chisum's cattle to Fort Sumner for several years.

In 1873, Chisum moved his headquarters from Concho County, Texas, to near the present site of Roswell, New Mexico, and laid claim, for his Jinglebob outfit, to some two hundred miles of the Pecos Valley, just on the western edge of *comanchería*. Even Goodnight, an intrepid trail boss and former Texas Ranger, waited until 1876 before moving 1,800 head of Durham cattle into Palo Duro Canyon—after first taking ten days to drive out the buffalo—and establishing, with John Adair, what became the JA Ranch, which ultimately ran 100,000 head of cattle on a million acres of the Texas Panhandle.

Meanwhile, their altered circumstances compelled the Comanches to adapt to a new, confined way of life. They had always been a flexible, eclectic, and adaptable people. But the adjustment demanded of them now was even greater than the one they had made, long before, in moving from the Great Basin to the mountains of Wyoming, or the later one made after acquiring horses and moving from the mountains out onto the Great Plains. Now, besides their relative confinement, the greatest change to which they had increasingly to reconcile themselves was short or undependable rations from their agency, as well as the accelerating scarcity of buffalo herds.

The Comanches had known physical hunger before reservation days. As early as 1818–1819, as a young man, David Gouverneur Burnet, first president of the Texas Republic, had "spent a considerable time with, or in the vicinity of, the Comanches of Texas." In a series of letters published later in the *Cincinnati Literary Gazette*, he observed that the southern Comanches often suffered from hunger during the summer months, when buffalo herds migrated north. Entire villages, he wrote, went some-

times "three or four days without a particle of animal or vegetables [*sic*] food." But, he added, the peoples' sufferings were shared, and if one hunter was lucky enough to make a kill, his game was "distributed gratuitously through the whole village."

A new and protracted period of want awaited the defeated Comanche nation on its reservation. Burnet had implied a salient characteristic of the period that lay ahead. In concluding his discussion of the Comanche diet, based primarily upon the bison, he noted ominously that "the number of buffaloes that annually reach the regions inhabited by the Comanches [meaning, in this context, the bands of Texas] has sensibly diminished within a few years." To Plains Indians the possibility that buffalo might someday disappear entirely from the plains was, of course, at that time unthinkable.

This was because many of the Plains tribes believed there was an inexhaustible supply of bison that issued from caves somewhere in the Southern Plains every spring and then traveled north. In 1879, for instance, four years after the surrender of the last integral Comanche bands, when the buffalo were already nearly gone, Stone Calf, a leading Cheyenne chief, assured Lieutenant Colonel Richard Irving Dodge, U.S. Army, that he knew the location of these caves, though he had never actually seen them. The Great Spirit, or according to Dodge, the "Good God," had provided the animals in order to furnish an eternal supply of food for Indians. No matter how prodigally tribal or white hide hunters might slaughter buffalo, they would never be able to exterminate them.

Furthermore, Plains Indians had been hearing predictions of the disappearance of the buffalo for at least thirty-odd years before Senator Henderson's admonition during the Medicine Lodge Treaty talks. The 1834 Dragoon expedition to the Comanches and the Wichitas (or "Pawnee Pict village," as they were then called) brought with them groups of Indians from other tribes, including some of those formidable enemies of the Kiowas and Comanches, the Osages. In a council held in his tent by Colonel Henry Dodge with the Wichita leaders early on the day the Comanches arrived, an Osage youth, Monpisha, addressed the Wichita chiefs, Wetarasharo and two others, concerning peace between his people and theirs and with the whites, beginning by saying that while he himself was merely a boy, his father had been an Osage chief. The youth went on to deliver what seems to have been, even then, the U.S. government's official line: His father had told him he had once been a "wild Indian." But white men had taught him how to build a house, raise cattle, and live like them. This had made his father happy. Monpisha had been sent to missionary school, where he had been taught to read and write. You, too, he said, can learn to do this, if you make peace with the white men. "*Your buffalo will be gone in a few years. Your great father, the President, will give you cattle, and teach you to live without buffalo*" (emphasis added).

This in 1834! No wonder the Plains Indians had not taken seriously warnings

by Anglo officials of the bison's forthcoming disappearance! Surely they had long before begun to discount them. But by 1875 the Comanches, and other reservation Indians, were already having to reconcile themselves to the rapid decline of the herds. There were still a few buffalo left, but those few were to vanish within another five years.

FOUR

While the Comanches on their vast reservation looked with longing to the past, settlers driving teams and wagons westward into a new region looked toward a future of promise. Their hunger was of another sort, far different from that of the nomads of the Great Plains. It was the hunger for land, not for land to wander over, hunt upon, and love—although love might come later—but to acquire and possess as an asset, an investment for the accumulation of wealth, to work upon and make fruitful, to build upon, raise families upon, maybe even to develop and sell for a profit. Some came to work the land, raise livestock and crops. Others came to found a community similar to the one they had left behind, to build their houses, general stores, banks, livery stables, smithies, churches, saloons, and jails. That is, communities in which to live and do business.

Henrietta, Texas, was such a place, just west of the ninety-eighth meridian, a little below the Red River, and some seventy-five miles south and a little east of Fort Sill. In 1860, when the region was still a risky place in which even to tarry, a group of brave and optimistic settlers surveyed a 160-acre tract into blocks and christened their town-to-be "Henrietta," a name earlier stipulated by Texas legislators when they had created Clay County in 1857. A number of farmers and ranchers moved into the area that year and the following one, forming a population of 107 whites and 2 free Negroes. But in all of Clay County, Henrietta, its seat of government, was the sole significant settlement, possessing a general store and about ten houses. It was a frontier community in a region that the Comanche people still believed formed part of their hunting grounds.

By the second year of the Civil War, about mid-1863, with federal troops committed far from the Southern Plains, "Indians"—almost surely Comanches—not only reclaimed this portion of their homeland but drove the sparsely settled frontier approximately fifty miles eastward. In 1865, at the end of the Civil War, another optimist, a doctor from Illinois, led eight or ten families to the deserted village, where for a time they lived in its abandoned houses, until they, too, were forced to flee. The census of 1870 recorded no population for Clay County.

There were formidable obstacles to settlement, especially for farmers, even beyond that of constant danger from Comanche and Kiowa war parties. It was

virtually impossible to grow crops with masses of buffalo roving the open range. The longhorns that were beginning to replace bison were hardly an improvement from a farmer's perspective. Furthermore, the lack of surface water over vast areas of the Southern Plains represented a serious deficiency. Farmers and those who would sell them goods were compelled to wait until American know-how and the resources of the industrial revolution provided solutions to problems of life upon a vast subhumid or arid region. As it happened, in 1875, when the "Indian problem" on the Southern Plains appeared at last to have been "solved" by the U.S. Army, other means were already at hand for continuing what was called "progress."

Fortuitously for settlers, barbed wire was invented in 1874. Ranchers and farmers required barbed wire to fence out, or confine, cattle. The industrial revolution also provided new equipment for drilling deep wells, along with improved windmills to raise water from far below the prairie for the use of ranchers, farmers, homesteaders, and their livestock. Beginning in the mid-1870s, ever greater quantities of barbed wire and windmills were sold to settlers pushing into land formerly the habitat of the buffalo. In addition, just as bison were being replaced by longhorns, the half-wild longhorns were themselves being replaced by Durham and Hereford cattle. William S. Ikard, for example, introduced a few Herefords into Clay County in 1876, and by 1887 he and his brother were raising registered cattle. Charles Goodnight in 1883 added twenty Hereford bulls to his Durham stock on the JA Ranch at Palo Duro.

In addition to problems caused by roaming cattle and the scarcity of surface water, there was the difficulty of transporting goods, even barbed wire and windmills, to the frontier. What roads existed were often abominable and lacked bridges. It was not uncommon for freight wagons to be delayed at fords when streams were high, or to become mired to the axles and to remain immobile for hours or days. But improved windmills, placed beside tanks to provide water for steam locomotives, made possible the advance of railroads across long, vacant spaces, so that necessities as well as passengers could reach the frontier.

Henrietta was once again occupied in 1873, the year before the Red River War. This group of settlers stuck it out, even though the Texas frontier was still a dangerous place—for whites and, of course, increasingly for Comanches and Kiowas. An itinerant crowd of buffalo hunters, passing through on their way westward to the Southern Plains, made the hamlet perhaps somewhat safer than formerly for settlers. But the Indians demonstrated their increasing hatred and desperation that June in a raid on a Brazos River farm in which a war party killed an infant and rode away with a seven-year-old girl. Would-be rescuers later found her scalped and dangling from a tree. If the raiders were Comanches, which was likely, the warriors' behavior had become anomalous for the tribe, since captured children of that age were frequently adopted by childless couples, or at least held for ransom.

By 1880, Henrietta's population had increased to four hundred. Two years later the Fort Worth and Denver Railroad, out of Fort Worth, Texas, reached that community. The town was incorporated the same year and soon became the seat of Clay County. It also became the leading center of trade for Fort Sill, from which by 1888 a regular stagecoach service had been established by Elias Daniel Jeter, who offered a round trip every two days, fording the Red River at Charlie's Crossing.

Lon Kelley, a photographer, and his student, Alice Snearly, were residents of Henrietta. But during the 1890s they moved north for several years to Duncan, a railroad town east of Fort Sill, located within the Chickasaw nation in Indian Territory. Gertrude, Kelley's wife and Alice's sister, went with them. Kelley took over a photography studio there, establishing a commercial enterprise. But it is interesting to speculate as to what other motives might have been present. True, photographs of Indians sold for more than pictures of Anglo settlers. But the photographers probably also saw, with the coming of railroads, how quickly the frontier was vanishing. Possibly they took a sympathetic interest in the Comanches and other Native Americans sequestered upon their Fort Sill reservation. They may have wished to preserve some of the faces and traditional garb of sons and daughters of the old chiefs, an interim generation of mostly young men and women who, while adapting to their present situation, were still intimately in touch with the tribal past. The advantage of Duncan was its proximity to Fort Sill. Their Comanche subjects would have had to ride but a few miles beyond the limit of the reservation in order to reach them.

FIVE

By the 1890s neither photographers nor Indians would have encountered even a lone buffalo bull en route. It is difficult to fix upon any single date for the disappearance of the bison. But about 1880 will do. That was the year the Kiowas, the Comanches' neighbors, were unable to locate a buffalo for their annual sun dance. The disappearance of the great herds was, of course, a catastrophe for the Comanches, Kiowas, Kiowa-Apaches, and other Plains Indians. The buffalo's near extinction emphasized, even more than confinement upon a reservation, the end of these hunting peoples' free way of life. When considered in that respect, the loss may be surmised to have created a psychological and spiritual sense of vacuity, since the buffalo was sacred to Plains Indians. But the loss was also responsible for many families, including those with young children, going physically hungry for long intervals—and becoming in the process almost entirely dependent upon the U.S. government.

Lieutenant Colonel Richard Irving Dodge summed up the Comanches'

predicament when he wrote in 1882 that "ten years ago the Plains Indians had an ample supply of food, and could support life comfortably without the assistance of the government. Now everything is gone, and they are reduced to the condition of paupers, without food, shelter, clothing, or any of those necessaries of life which came from the buffalo . . ."

That this had occurred was ironic in the extreme. Congress had reluctantly authorized rations for reservation Indians as a supplement to the meat they were expected to acquire by hunting. The army had even permitted Comanche men to remain sufficiently armed so that they might hunt. They had also allowed all warriors to retain an indeterminate number of ponies for this purpose. In the most lenient instance, Colonel Ranald Mackenzie had authorized the return of five hundred head to the Kwahadas out of their herd of two thousand. Previous divisions and bands had, of course, been treated less generously upon surrender—those groups, that is, who had used the reservation as a source of food and as a base for raids into Texas. But all of the Comanche men were allowed to keep at least a pony or two.

Of the remaining horses turned in the previous fall, 650 had been distributed to Tonkawa and white scouts, while another 760 had either died owing to their poor condition or been shot on orders from the post commander, Lieutenant Colonel J. W. Davidson. The air around the post had soon become so malodorous that the colonel had reconsidered and auctioned off another 590 of the animals at an average price of six dollars a head, with the proceeds, designated the "Pony Fund," being held for the tribe.

The effect of these events on the defeated Indians' morale is not hard to imagine. Now, in addition, it must have seemed that the Grant administration was perpetrating a perverse joke by permitting them to retain some ponies for hunting while at the same time failing to deter white hide hunters from slaughtering buffalo—the principal source of their sustenance—literally by the millions.

Colonel Dodge, whose experience spanned thirty years on the Plains, estimated that from 1872 through 1874 some five million buffalo had been slaughtered. By 1871 tanneries in America and abroad were employing newly devised methods that rendered buffalo hides as valuable as cowhide. Besides, in another ironic development, someone had discovered that tough bison leather made effective belting for the machines of the industrial age. Consequently, stiffened skins of the animals might bring as much as three or four dollars apiece.

As late as the spring of 1871, Dodge had observed the buffalo moving northward with the greening grass "in one immense column, oftentimes from twenty to fifty miles in width and of unknown depth from front to rear." He described the change he found from 1872 to 1873 after riding out with some English sportsmen: "Where there were myriads of buffalo the year before, there were now myriads of

carcasses. The air was foul with sickening stench, and the vast plain, which only a short twelvemonth before teemed with animal life, was a dead, solitary, putrid desert." It was the triumph of the bottom line.

Even so, causes other than methodical slaughter by white hide hunters contributed to the buffalo's near extinction. Anglo-American greed was the leading cause, of course, but only one of several. The historian Dan Flores has observed that other factors, such as commercial hunting by Plains Indians, with their preference for cow hides; wolf predation upon the calf population; cycles of drought; and brucellosis, a disease causing cows to abort, also played a part in reducing the numbers of the herds. So did, to a lesser extent, hunting by settlers, sportsmen, professional hunters engaged to feed railroad crews, and even passengers firing from the windows of transcontinental trains.

Furthermore, as another historian, Richard White, reminds us, Congress in the 1870s actually did pass a bill to protect the buffalo, but President Grant refused to sign it. Presumably the old soldier agreed with General Philip Henry Sheridan's argument that by eliminating the great herds from the Plains, hide hunters were destroying the Indians' commissary, without which they would no longer be able to resist settlement, or even to exist upon the prairie. Clearly there was a conscious military, as well as a monetary, motive for eliminating the buffalo herds.

Beginning about 1875 the Comanches, Kiowas, and Kiowa-Apaches began suffering from intermittent shortages of rations. Although the recurrent shortages became less frequent and acute by the mid-1880s, they persisted in a less critical form through the end of that decade. By the early 1890s, the three peoples had become more nearly self-sufficient, owing to increased appropriations by Congress as well as to income from grazing leases upon reservation land. Meanwhile adults and children of the three tribes often went hungry, since much of the game had been hunted out of the three-million-acre reservation by the year the Kwahadas surrendered. The Indians had few resources and could afford to neglect none. One of these resources forced a distasteful adaptation upon them, turning proud Comanche warriors into beggars.

The great cattle drives to Dodge City, Kansas, and destinations farther north began in 1876 on the Western Trail, which from its inception superseded all other trails for drovers moving herds to the Dodge railhead or to stock northern ranges. Starting in south Texas, cowboys trailed their cattle northward to Fort Griffin and from there to Doan's Crossing on the Red River. At Doan's, after 1878, a rancher not only might meet his trail boss to learn the condition of the herd but also might stay in a hotel, the Bat's Cave. The last roundup before crossing into Indian Territory took place at Eagle Flats, only fifteen miles to the south (now Vernon, Texas) of Doan's, so that an owner could be sure of an up-to-date report.

After fording the stream at Doan's, the trail continued north, at times briefly

within Greer County (claimed by Texas until 1896 when, by an act of the U.S. Supreme Court, it was attached to Oklahoma Territory), then traversed for some distance the western limit of the reservation. Along this latter stretch the Indians made a practice of demanding toll from drovers, sometimes having to compete with cattle thieves, who felt safer in "the nations" across the river from Texas.

"Teddy Blue" Abbott came up the trail in 1879, crossed at Doan's, and encountered only outlaws who "popped a blanket" at night, stampeding the herd. Abbott and a companion tracked the thieves the next day and recovered the big lead steers they had cut from the herd. (Teddy Blue did not record what happened to the rustlers.) But Andy Adams, in his novel *The Log of a Cowboy*, describes an encounter with hungry Indians. Although the book is fiction, Adams knew the trail drive from about a decade of personal experience. His treatment of that phenomenon is generally considered to be accurate to the spirit of the drive, if not invariably to the letter: About forty miles north of Doan's Crossing, Adam's narrator spies a party of about a hundred mounted Indian men and women ahead on the trail. As the herd approaches, a man, apparently a chief, kicks his pony forward and raises a palm, "as if commanding a halt." After shaking hands, the lead cowboys, or "pointers," discover the brilliantly garbed chief to be a Comanche, with two unlikely Spanish-speaking Apache interpreters (unlikely because most Comanches, especially leaders, spoke some Spanish during this period). Adams goes on to describe the Comanche, possibly relying upon accounts by friends or, perhaps in part, upon his own memory.

In his romanticized description, the chief

> dropped his blanket from his shoulders and dismounted from his horse. He was a fine specimen of the Plains Indian, fully six feet in height, perfectly proportioned, and in years well past middle life. He looked every inch a chief, and was a natural born orator. There was a certain easy grace to his gestures, only to be seen in people who use the sign language, and often when he was speaking to the Apache interpreters, I could anticipate his requests before they were translated to us, although I did not know a word of Comanche.

Why had the party of Comanches halted the herd? "Before the powwow had progressed far it was evident that begging was its object." After referring to the slaughter of the buffalo by white hide hunters, the chief speaks of the "consequent hunger and poverty amongst his people." He demands "ten beeves" for the privilege of passing through his hunting grounds. An extended parley takes place. Finally the Comanches agree to accept "a big lame steer and two stray cows," which they drive away toward their encampment, leaving the drovers and their herd free to proceed.

The point here is that Adams was relating what he took to be a representative event on a typical trail drive through what cowboys called "the nations." In doing so, he was demonstrating that Comanches or the other reservation Indians frequently halted trail cowboys and demanded cattle as toll for the herd's passage—a great comedown, from the Indians' perspective, from the old days when Comanche warriors would simply have slain resisting drovers while stampeding and seizing the entire herd.

After 1875, the 1834 oration of the Osage youth Monpishu, followed by the 1867 admonitions of Senator Henderson at Medicine Lodge Creek, proved prophetic for the Comanches. The result, though, cannot have been what the U.S. government had intended. For example, in 1879 and again in 1883, the government distributed breeding cattle to the reservation Indians. While a few Comanches began creating small herds, many recipients sold their livestock for pittances to whites, in some instances apparently in order to gamble with the money. A number of the purebred bulls died of tick fever. Hungry families consumed other cattle, while others of the select livestock died in storms on the open range, and white rustlers stole others. The program was not a success.

Thereafter, until the 1890s, most of the cattle the Comanches saw were "beef on the hoof," animals driven to the reservation for Indian rations. These, especially in winter, were apt to be scrawny, with little beef upon their bones. Still, by around 1892 the majority of Comanches had acquired a few cows, while some among the tribe had nurtured their holdings into modest herds, so that most tribal members were prepared when rations ceased, except to the old and infirm, in 1901. But for hungry people in the 1870s and 1880s, more prosperous times lay ahead, out of sight in the future.

In those two earlier decades the Comanches had coaxed a little subsistence from soil largely unsuitable for that purpose. A small proportion of Indian children had gained some education in reservation schools, although others had died there of various "civilized" diseases. The idea of education had gained a few adherents, including Quanah Parker, but it was hardly a success during the reservation years.

SIX

Throughout the 1870s and 1880s, humiliated by defeat, the Comanches were still feeling themselves to be prisoners—which, owing to the proximity of Fort Sill and the watchful eyes of Indian agents, they surely were. A prevalent attitude among the Comanche men was probably expressed by one warrior who hung his buffalo-scalp war bonnet on a branch, regarded it for a final moment, and remarked, turning away, that a defeated man no longer deserved to wear such a headdress. Even

the tribe's psychic freedom was under stress. The Comanches held their last sun dance in 1878, but afterward abandoned the ceremony no doubt owing to Indian Bureau disapproval as well as to the presence of white spectators, with the consequent tribal discomfort at the lack of privacy now associated with a sacred ritual.

Fortunately about this time an old means of obtaining power and access to the sacred, formerly used by medicine men for prophesy and curing and sporadically by other individuals, presented an escape from the sense of physical and, especially, psychological entrapment and impotence from which the Comanche people undoubtedly suffered. The peyote religious ceremony, which owes its psychological and spiritual effectiveness to the hallucinogenic qualities of the peyote button, served to compensate for much that had been lost.

The peyote plant is a cactus native to Mexico and the southwestern United States. Of a pale blue color, it bears little pink flowers and develops a fuzzy buttonlike crown known as the "peyote." This button, when detached, becomes a kind of sacramental wafer for those chewing it and participating in its ceremony. While non-habit-forming, the mescaline and other chemicals contained within the button produce visual and auditory hallucinations—visions. Those partaking in the ceremony—which involves prayer; songs to drum and rattle; eating the button; and receiving a vision, usually in vivid colors—feel a strong sense of fellowship, peace, and harmony, often of spiritual fulfillment. Tribal adherents believe the experience is not only psychically valuable for all those participating but also curative for any individual who is ill and chooses to come to a group of them for help.

The Comanches say they acquired the formal peyote ritual from the Apaches, and various accounts and legends support this belief. The adoption of the peyote ceremony—like the People's earlier acquisition of Plains cultural traits such as the vision quest—provides further evidence of the Nuhmuhnuh's open-minded eclecticism. Indeed, the peyote ritual provided another form of vision quest to a people who had always valued dreams and visions, unsought or sought. Apparently the tribe had possessed this potent "medicine" before reservation times. On the Plains it was used occasionally by hunters or war parties in attempts to divine the future before setting out to fulfill their objectives, or by a medicine man for curing, but it was not until all Comanches were restricted to their reservation during the later 1870s that its use became common. Relatively frequent sessions occurred at first among small circles of men, under such leaders or peyote "roadmen" (that is, those who had chosen the peyote "road") as Quanah Parker, who, by example, popularized the ritual, leading to its increasing use among other groups of men on the reservation.

By 1883 at the latest, all-night peyote sessions held within a tepee around a fire were becoming more and more frequent. The final widespread acceptance of the peyote ritual among Comanche men during the 1890s was not only an example of

the People's resilience and their ability to adjust to hardship and frustration but was also a natural extension of an important aspect of their traditional culture: their relationship to the supernatural. Even though physically restricted, Comanche men (and a few women) could seek supernatural power, "medicine," as well as psychic reassurance through visions induced by the hallucinogen.

The peyote ceremonies gave their lives a renewed significance. The setting within a tepee ensured privacy and reinforced feelings of tribal solidarity. This last was critical. The ceremonies, which were followed by breakfasts prepared by and eaten with their wives and female relatives in a friendly and relaxed social context, helped to preserve the political and social structure of the tribe. Indeed, the anthropologist Morris W. Foster believes that "the rapid, widespread adoption of peyotism within the Comanche community can be explained primarily by the prevailing necessities of community organization. . . ." In other words, frequent observance of the peyote ritual was a powerful means not only of reinforcing tribal unity but of selecting leaders and maintaining leadership within that community. Perhaps it is not too much of a stretch to suggest that the peyote rite, with all its ramifications, was—during a difficult period—the most important means the People possessed of preserving their culture and, with it, their very identity as "Comanche."

That Comanche leaders had rediscovered the virtues of peyote at this time was another major irony in the history of their reservation years, one with comical aspects in light of simultaneous developments among humanitarian reformers in the east. The historian L. G. Moses notes that from 1883, when Buffalo Bill Cody's Wild West Shows began, to the 1920s, reformers worried that displays of riding and roping and enactments of attacks on the "Deadwood Stage"—which, incidentally, were enjoyed by most of the Indians who participated in them—emphasized the Native Americans' "savagery by celebrating their martial spirit." They considered such behavior, even as sport or spectacle, "uncivilized."

In the 1800s entire societies of well-meaning individuals concerned with the welfare of "the Indian" sprang into being. One group, for example, which extended its membership across the country, was the Women's National Indian Association, often affiliated with churches. Another, more powerful, organization, formed in Philadelphia in 1882, was the Indian Rights Association. Made up of male community leaders, this organization over the years exercised a great deal of influence upon the national Board of Indian Commissioners and, ultimately, upon Congress itself. There is no doubt that it played a major role in creating United States Indian policy.

The Rights Association's goal was to "civilize" the Indian—that is, in this instance, to turn formerly hard-riding Plains fighters into hardworking, tax-paying farmers. To accomplish this they wished to destroy existing tribal relations and culture. They believed that the first means for achieving this destruction was the abolition of existing reservations. Each family was to be placed separately upon its

own homestead. They wished to see Indians become citizens, with both the rights and, especially, the legal responsibilities of American citizens. Finally, they envisioned a governmental educational plan that would foster individualism and independence among its students. The plan would instruct adults if they were willing, but it would be obligatory for children, whether or not they or their parents wished it.

In other words, what the reformers wanted to see was not far removed from the vision the framers of the Medicine Lodge Treaty had had some fifteen to twenty years before. Senator Henderson and the other commissioners had wished to see contented farmers who, with their families, had moved into the Anglo-American mainstream. Although the reformers were unaware of it at the time, and even later, it was peyote medicine and the resilience of the Comanche people that defeated their cherished fantasy.

The peyote ritual was in fact so much in harmony with certain Native American beliefs and attitudes concerning the supernatural that it soon spread to other tribes on and beyond the reservation. Wallace and Hoebel point out that peyote worship spread first to the Kiowas, Wichitas, Pawnees, and Shawnees before 1900, and to numerous other tribes afterward. They believe this transference to have been "perhaps the most important cultural contribution of the Comanches to the lives of other American Indians." For some Native American individuals the peyote ritual was literally life-saving "medicine," in both the physical and spiritual sense of the word.

Edward S. Curtis writes (in "The Oklahoma Indians: Peyote Experiences") of a Cheyenne man who, in the early 1900s, was saved by peyote. He had been an alcoholic and had lost everything of value to him, including his wife and children. Finally, when he was lying drunk, a wagon ran over him and crushed his chest. While he was recovering, a friend persuaded him to join a peyote group. Completely losing his craving for whiskey, or so he claimed, this graduate of Carlisle (a training school for Native American children established in rural Pennsylvania in 1879) recovered his health and rebuilt his life. A few years later he was a successful farmer, caring for his children and helping any fellow tribal member who was in trouble.

Curtis also cites the instance of a Ponca man he had interviewed. This sixty-year-old individual had tuberculosis and had wasted away to ninety-five pounds. He too joined a peyote society. Within a year, he claimed, he had become "like a young man" and had nearly doubled his weight. He also declared that the peyote experience had made him "think about other people." Whatever social, psychological, and religious forces were at work here, these testimonials would seem to indicate that the peyote fellowship could produce a curative effect upon at least some Native American individuals. Daniel Gelo observes that he has heard similar testimonials from Comanche people today.

Naturally during the early years, the increased frequency of peyote meetings among the Comanches caught the attention of the Indian Bureau. In 1888, Agent E. E. White attempted to forbid the ingestion of the cactus buttons, but the Comanches were united and firm in resisting his order. They finally compromised by agreeing to hold the sessions only one night during each full moon and to desist entirely after they had exhausted their supply of the drug. But somehow, as if by magic, that supply continued to renew itself, the buttons even being sold in some local stores such as Doan's, across the Red River. As time went on, peyote meetings continued to increase in popularity until by the time of allotment in 1900 almost every Comanche man had attended a session at one time or another.

The Comanches did not convert from hunters and warriors to happy farmers. The reservation period—1875 to 1906 for our purposes—occurred long before the present concept of multiculturalism was even conceivable to those wielding power or to the general public. During those decades, the proposition that the values and way of life of hard-working Anglo farmers might not be appropriate for a tribe of defeated pastoral hunter/warriors never entered the minds of humanitarian reformers or of United States congressmen or of the government officials responsible for the Indians' well-being. How could it have? The prevailing view of American Indians at that time was that they were simply backward, "savage" as opposed to "civilized." The doctrine promulgated by reformers, such as the powerful Indian Rights Association, and adopted by the U.S. government was assimilation. Indians, whether "unequal" or "equal" to Anglos—and there were arguments on both sides—must be made to assimilate, to "catch up" and blend with other Americans. After all, a popular slogan of the day was "You can't stop Progress!"

So with intermittent shortages of rations, and with Comanche men protecting their cultural identity as hunters and warriors by resisting, for the most part, the unworkable injunctions of the Indian Bureau to farm or raise cattle, children of the tribe frequently went hungry. The period during which the Comanches suffered the most severe food shortages lasted at least until 1884, when some members of Congress began to be aware that a near-desperate situation existed on the reservation and increased appropriations for rations. Texas cowmen also helped with contributions of steers "on the quiet" in return for the privilege of illegally grazing their longhorns on Indian land.

SEVEN

Strangely enough, in another implausible development, a few powerful Texas cattlemen—representatives of a people who had been the Comanches' most hated enemies—ultimately became their most valuable allies against those settlers living at

the edge of the reservation, or squatting upon it, who wished to acquire the Indians' land, not as pasture for temporarily grazing cattle but as terrain for building their houses and fencing their farms upon, or for filing mining claims upon. These late-comers were labeled "boomers," and they consisted of developers, newspaper editors, and railroad entrepreneurs who promoted "growth" and who had an economic interest in an increased white population.

Boomers and their followers hungered for free land, complaining that the Comanches were not using all of the land deeded to them in perpetuity by the Medicine Lodge Treaty, and arguing that reservation acreage should be opened to white settlers who would "improve" it. After Congress created Oklahoma Territory in 1890, the boomers made their views repeatedly known to their representative in the House. While that representative was unable to vote, he participated in debate and was authorized to introduce bills, so he wielded some influence. Across the Red River, Texas boomers pressured their congressmen, who were torn between supporting these noisy but small-time constituents and the big cowmen.

The curious alliance between Texas cattlemen and Comanches came about because, with an open range, it was impossible to keep Texas cattle away from the prime grazing lands of the reservation—especially when their owners wished to see them there. In 1878 Congress passed a measure authorizing Indian police. Three years later the Comanche-Kiowa-Apache force was spending most of its time attempting to oust non-Indian cattle from the reservation. At first Indian Agent P. B. Hunt resisted overtures from cattlemen desiring to lease grazing land. Nevertheless, the ranchers had already begun building corrals and setting up line camps on Indian land, clearly with the cooperation of some of the leading chiefs, who were "hired" for small monthly salaries.

By 1885 Hunt had become persuaded that leasing land to the cattlemen was probably in the best interest of his charges. That same year Secretary of the Interior Lucius Q. Lamar, though concerned about the legality of the arrangement, nodded an uneasy assent while in effect looking the other way. It was not until 1892 that the Office of Indian Affairs openly recognized the legality of the leases. But the Indians themselves had long since become aware of the benefits associated with these documents. They looked forward to the annual "grass payments" and wished them to continue indefinitely.

But this was not to be. In a further occurrence replete with irony, the idealists of the Indian Rights Association acquired allies they might not have entirely approved of had they known much about them, that is, the boomers. The reformers had been lobbying Congress to abolish Indian reservations, to place individual Indians on separate homesteads, and to open the "surplus" land to white settlement. This was to be for the Indians' own good, to help them assimilate. It also happened to be exactly what the boomers wanted, although they had little interest in the

welfare of the Indians. On the contrary, some were already illegally squatting or prospecting on Indian land, and while many were simply land-hungry farmers, others were lawless men quite willing to steal timber or even cows and horses from the reservation. Over the years the boomers locating around the reservation had increased in numbers, and they too had continued to lobby their congressmen.

The first result of these joint efforts was the Dawes Severalty Act, which Congress passed in 1887. This act in effect legalized the breaking up of Indian tribes, the division of their commonly held land into tracts of various sizes, and the distribution of land to individual members, authorizing a maximum of 160 acres to each head of a family. Of course, the government had no intention of releasing *all* of the communal land to these individuals. The land remaining after each tribal member had received his or her portion, however much or little that might be, was designated for distribution among the clamoring white population of boomers, sooners, squatters, and others. Congress followed the Dawes Act two years later with the establishment of the Cherokee Commission, a body created to negotiate with the Cherokees and other tribes claiming Indian Territory land lying west of the 96th meridian.

The Comanches, Kiowas, and Kiowa-Apaches were understandably alarmed by these developments. Although their own reservation was not immediately affected, the Dawes Act empowered the president at any time to order the three peoples to move to individual allotments on their reservation, with the remainder of their land going to the boomers. Having already lost the buffalo, upon which they had once depended for almost all of their material needs, they now faced the prospect of losing what land remained to them out of *comanchería*, their enormous former domain.

During the drawn-out years of contention that followed, the Indians' principal allies continued to be the "Big Five" Texas cowmen—Samuel B. Burnett, Daniel W. Waggoner, E. C. Suggs, C. T. Herring, and J. P. Addington. These men wished to continue leasing reservation land at bargain prices, and they not only lobbied their congressmen but, for instance, in 1890 paid rail fares to send influential chiefs such as the Kiowa Lone Wolf, the Kiowa-Apache White Man, and Quanah Parker to Washington accompanied by Burnett's and Waggoner's attorney. As a result of this trip, the secretary of the interior approved what might be called a sweetheart deal for the five prominent cattlemen, allowing them to lease, without competition from other ranchers, over a million acres at six cents per acre.

The cattle barons wanted six-year leases, but all those offered were for only one year, and these had to be renegotiated annually, entailing more trips by Quanah and his fellow delegates to Washington. But in 1898, the Office of Indian Affairs offered three-year leases—with a catch: an increase in price to ten cents an acre. Waggoner, Suggs, and Burnett protested and sent Quanah Parker, as well as

representatives for the Kiowas and Kiowa-Apaches, once again to lobby the commissioner of Indian affairs. This time the secretary of the interior held firm. The cattlemen ended by signing what virtually were to be their final leases for reservation land.

Because the chairman of the Cherokee Commission was an ex-governor of Michigan named David Jerome, the agreement forced upon the Comanches, Kiowas, and Kiowa-Apaches became known as the Jerome Agreement. It might just as accurately have been designated the "Jerome Disagreement." Basically the three tribes were opposed to yielding any of their land. But for approximately three weeks in the fall of 1882, Jerome and his two fellow commissioners argued, schemed, and threatened until they finally succeeded in collecting a few signatures more than those of three-fourths of the grown male population of the three tribes, a requirement stipulated by the Medicine Lodge Treaty for selling tribal lands.

The terms of the offer could hardly have been appealing to a people who not so many years before had claimed as their home range most of the Southern Plains. Jerome promised 160 acres for every tribal member, with one half in agricultural land and the other in grazing land. For the "surplus" land he offered a lump sum of two million dollars. Whenever Quanah and the other Indian negotiators would resist, Jerome would contrast his offer to the Dawes Act, which provided for Indian families in an even more meager fashion. In the end, the Cherokee Commission got what it wanted, but the agreement was one in which later Americans could take little pride.

One man among the Indian negotiators, a Kiowa named Komalty, made the point—brushed aside by the commissioners—that reveals the inadequacy and unfairness of the agreement. Komalty contended that it would be impossible for people to raise livestock on only 160 acres. Since fifteen acres were required to feed one cow, a would-be Indian rancher might hope to support about ten head of cattle— not much of a herd. Nor could many live comfortably by farming in a region where most of the land was principally suitable for grazing, despite Senator Henderson's 1867 promise of "comfortable homes upon our richest agricultural lands."

These facts also applied to Anglo homesteaders taking advantage of the Federal Homestead Act of 1862. The Texas historian Walter Prescott Webb, who wrote wisely concerning land and water on the Plains, deplored certain laws for the West written by men of the East, noting that a genuine ranch in this subhumid to arid region averaged from two thousand to fifty thousand acres. Cowmen, he observed, found means, whether legal or illegal, to enlarge their ranches to adequate size. "In their opinion," he went on to comment, "a man who owned only 160 acres of Plains land was more to be pitied than ridiculed. That amount of land was not enough to do him any good: it merely made him an obstacle to those who knew 'what the country was good for.'"

In 1892 the Cherokee Commission presented the U.S. government with a *fait accompli*. Fortunately Congress failed to ratify the Jerome Agreement for another eight years, permitting the cattlemen to lease reservation grazing land throughout this period, and allowing the Comanches and their former allies to continue receiving annual grass money. During this interval the Indian Rights Association took an increasing interest in the Comanches, Kiowas, and Kiowa-Apaches, still wishing to "detribalize" them but also desiring to ensure that they received fair treatment. About the same time, the boomers found a powerful source of support in the Rock Island Railroad, one line of which ran along the northern limit of the reservation, with another along its eastern edge. Naturally, it was advantageous to the railroad to have heavily populated communities along its routes. Consequently the railroad added its voice to those lobbying in Washington for opening the region around Fort Sill to white homesteaders.

EIGHT

Meanwhile, in 1894, the remnants of another band of Indians joined the Kiowas, Kiowa-Apaches, and Comanches on their reservation. These people, like the Kiowa-Apaches (now known as the "Apache Tribe of Oklahoma"), were Athapascans, representatives of a widely spread language group that included Navajos and a multitude of Apache bands with various names. The Comanches probably did not remember their own ancient victory, but they had driven the Plains Apaches from what had become *comanchería* by 1750, and after that had fought mounted Lipan Apaches wherever they could find them, usually in far southern Texas. The Navajos had long been their enemies too. But Comanches now stood alongside Kiowas and Kiowa-Apaches waiting curiously to welcome a trainload of Chiricahua Apaches to Fort Sill.

These Athapascan people, the remainder of the Chihenne (or "Red Paint People") band, under the leadership of Geronimo, had been prisoners of war since their 1886 surrender to General Nelson A. Miles in Skeleton Canyon, Arizona. They had spent eight years in far away Florida and Alabama feeling deprived, homesick, and miserable, while suffering heavy losses from disease. When the Chiricahuas arrived at Fort Sill on a special train, the Comanches and Kiowas tried to communicate with the newcomers by sign language, but the effort was futile. The Apaches were not Plains Indians and could not understand them.

Still, the hapless Chiricahuas must have detected sympathy mingled with the curiosity upon the features of the Indians who welcomed them and who themselves had experienced many of the hardships and some of the despair the newcomers had suffered during their long period of exile. In addition, the Chiricahuas

soon discovered, doubtless to the pleasant surprise of both peoples, that they shared a common language (despite differences in pronunciation as well as in vocabularies) with the Kiowa-Apaches, a northeastern band that had long ago—apparently for defensive reasons—attached itself to the Kiowas and become Plains Indians.

Though technically prisoners of war until 1913, the Chiricahuas soon built wooden cabins in villages apart from the other tribes and, despite their fearsome reputation, quietly settled down to become successful stock farmers on a modest scale, raising vegetables in garden plots, caring for the cattle distributed to them, and haying—all under military supervision. In this respect, they adapted quickly and easily. Agriculture was not foreign to them, as they had probably originally learned some of its techniques from the Pueblo Indians of New Mexico. As early as 1719 an expedition from Santa Fe, led by Spanish Governor Don Antonio Valverde Cosio, found Plains Apaches at the base of the Sangre de Cristo mountains cultivating fields of maize, beans, and squash and complaining about raids against them by those new horsemen of the plains, the Comanches. In another paradoxical twist of history, they now adjusted more quickly and easily than their former enemies.

In 1913, released by an act of Congress, the surviving 258 Apaches (out of the 296 who had arrived at Fort Sill) were permitted to choose either to remain in Oklahoma or to join the Mescalero Apaches in New Mexico. The majority, 171 individuals, chose to settle in southern New Mexico, closer to their former Arizona mountains and deserts. The 87 Chiricahuas who chose Oklahoma sold their cattle, which over the years had multiplied into a good-sized herd. With the proceeds, each family was able to purchase an eighty-acre homestead of reservation land from the Kiowas, Kiowa-Apaches, and Comanches. Today the descendants of those 87 people live in an area north of Fort Sill, and just north of the Comanche County line, in the vicinity of a town named, appropriately, Apache.

NINE

The Indian Rights Association had long championed the ideal of assimilation as promising the optimum future for Indian peoples. But in 1898 they did protest the allotments specified for the Comanches and the two other tribes under the Jerome Agreement, finding them too small and recommending instead allocations of no less than 480 acres. The following year a Department of the Interior report went further, recommending tracts of at least 1,000 acres for each Indian family. The Rock Island Railroad, however, persisted in its opposition to allotments larger than the 160 acres stipulated in the agreement. But ultimately the railroad was persuaded to accept the provision that an additional 480,000 acres from the total amount of surplus land be set aside for the Indians and remain the common property of the

three tribes. In the end, in the spring of 1900, Congress ratified the Jerome Agreement under terms that provided each individual Indian with 160 acres of land. Another 480,000 acres was to be owned in common by all Comanches, Kiowas, and Kiowa-Apaches. The three tribes were also guaranteed a minimum of $500,000 out of the two-million-dollar purchase price for the extra land, with the remainder to revert to them if Choctaw and Chickasaw claims on the property could be settled. As it turned out, the Supreme Court denied these claims that December.

The Comanches and associated tribes endured a final disappointment regarding their land six years later. Dissatisfied with gaining a mere 13,000 homesteads, the boomers had begun almost immediately to agitate for opening the last 480,000 acres owned in common by the three peoples, especially for a prize tract of approximately 400,000 acres by the Red River called the Big Pasture. The Indian agent for the three tribes, James F. Randlett, fought hard for his charges, but with only limited success, and that owing principally to President Theodore Roosevelt's sympathy for the Indians. Apparently aware that passage of a bill to open the last portion of the reservation was inevitable, Randlett, and his successor, John P. Blackman, pressed for 160-acre allotments to be distributed to Indian children born after the ratification of the Jerome Agreement.

In late winter 1906 a bill to open the 480,000-acre tract reached the president's desk. But Roosevelt sent it back to Congress, threatening a veto unless it included more favorable terms for the three tribes. The amended bill, as returned by Congress, stipulated an allotment for each Indian child born after 1900, as well as a fairer price per acre for the remaining huge and valuable communal tract. In June of 1906 President Roosevelt signed the rewritten bill into law.

By 1906 the Comanche people and their former allies had lost just about everything that had given their lives meaning prior to reservation days: their herds of ponies, representing their wealth; their buffalo hunts and the sacred buffalo itself; their free nomadic way of life, with its changes of scene among familiar and beautiful landscapes, its drama, and its war honors; and now almost all of the three million acres granted to them in perpetuity by the Medicine Lodge Treaty of 1867.

Making a bad situation even worse, and amplifying the Comanches' sense of loss, a smallpox epidemic during the winter of 1900–1901 snatched away 163 members of the tribe. The surviving Comanches—now wards of the U.S. government without even the right to vote, and placed separately on 160-acre homesites—were left impoverished, bemused, and probably wondering "What next?" as they struggled to adapt to all these changes.

And yet, for an adaptable people, there were a few consolations. There was, for one thing, the peyote rite, which continued the contact with traditional supernatural forces for all the "Roadmen" and their followers. Peyote also helped to maintain tribal unity and leadership. For those families who had converted to a Protestant

sect, Christianity was a comfort, in addition to the social life involved with church affiliation. There was also the day that the cattlemen paid "grass money." Similar to it was issue day, when annuities or rations were distributed. Both of these days were like holidays, occasions when Comanche men, primarily, could gather on horseback, chat, and exchange news.

Furthermore, hardship owing to acute food shortages had diminished by about 1885 and had ended by the 1890s, when increased grass payments as well as some farming on a modest scale or the raising of a few cattle rendered the People relatively more prosperous. Indeed, some families even used their money to purchase wagons and lumber for houses. Not least important, during the years from 1894 through 1905, two honest and competent Indian agents, Frank D. Baldwin and James F. Randlett, both former army officers, fought hard for them, although by no means always successfully, against all the grasping individuals and groups who sought to take advantage of the Indians' relative powerlessness.

In 1911 the tribe suffered another loss, this time that of a leader who had become a celebrity. When Quanah Parker died, more than a thousand people came to his funeral. Parker has been called "the last Comanche war chief." Historians and the public in general have made much of him. Today the traveler from the west enters Lawton, Oklahoma, on State Route 62, part of which is identified as "The Quanah Parker Trailway." Across the Red River in Texas the town Quanah is named after Chief Parker. But not all Comanches, past or present, have admired him equally. Recently a Comanche woman was heard to murmur, with regard to his current status, "They have practically deified him."

Parker, brave and intelligent, was a born leader—and a born politician as well. After the Kwahadas surrendered, he demonstrated an exceptional aptitude for dealing with the Anglo victors, from Texas cattle barons to a succession of Indian agents. In the process, like most politicians, he took care of himself very well. The cowmen paid him, along with several other leading Comanches, a monthly salary. Cattle king Burk Burnett built him a fine home, Star House, in return for the chief's long cooperation in lobbying Washington in favor of renewing reservation grazing leases. Charles Goodnight, apparently simply because he liked him, gave him a Durham bull so that he might improve his modest herd. Most Indian agents tried their best to protect him from the more annoying policies of distant officialdom.

Yet Quanah had his rivals and detractors within the tribe, where factions existed, for instance, in favor of and against leasing, and—even more controversially—for and against signing the Jerome Agreement. As a cooperative chief, Parker held a sporadic position as judge in the Court of Indian Offenses. Generally, the security of his position and his power derived from his value to white Indian agents and from the esteem in which he was held by them. For this reason they were willing to overlook, or even defend, his traditional braids, his seven wives, and his role as

peyote leader—all disapproved of by Washington. As a matter of course they supported him against opposing factions. One exasperated agent, Major Frank D. Baldwin, went so far on one occasion as to express his ire against Frank Moetah, a leader of the anti-Quanah faction, by characterizing him as "worthless" and "good-for-nothing."

Parker, on the other hand, has been criticized for making insufficient use of his power to thwart the Jerome Commission and the consequent, hated "Agreement." Yet if there was one thing Quanah understood thoroughly it was power. He knew that the victorious Anglo-Americans, represented by Washington, had absolute power to do what they wished, for, against, or with the Comanche people. That he was correct was later proven by the 1903 *Lone Wolf v. Hitchcock* decision by the U.S. Supreme Court. This decision stated, in effect, that Congress had the right to alter, or even cancel, the provisions of any treaty with American Indians. Chief Parker knew that only the *terms* could be negotiated in any "agreement" with the United States government. Congress would ultimately get what it wanted. Consequently he had struggled for delay and for more generous terms. Now, at Quanah's death, the government decided he would indeed be the last Comanche chief. In the future it would recognize no more chiefs but would deal only with the "Business Council."

TEN

The transition from reservation days to the present evolved out of a series of gradual changes that might be visualized as the "acculturation trail." Along this path are some important dates that may be compared to topographical landmarks. The turn of the century, 1900, coinciding with the year of allotment, is the first of these, standing like a bluff with a rock slide blocking the trail to the past. Until that time Christian missionaries had achieved little success in converting Comanches to their religion. But after each tribal member had occupied his or her separate plot of land, many Comanches joined Protestant denominations. Even so, most families were at that time still dwelling in tepees, albeit of canvas rather than buffalo hide, and assembling for winter and summer dances. Few spoke English. Yet as the years passed, more and more people moved indoors, until by 1926 virtually all Comanches were living in mostly government-built houses scattered throughout the countryside surrounding Fort Sill and Lawton. In another, sadder, development, by the mid-1930s the greater part of the tribe had lost its land, except for plots immediately adjacent to their houses, owing to a member either having been born after the allotment deadline or having sold his or her share in the title.

The next prominent landmark was the Second World War, specifically the early 1940s, with the Pearl Harbor bombing and the United States' entrance into the

conflict in 1941. This landmark towered in time like a giant signal rock whose trail joined two plains, a great "before" and "after." By the late 1940s the tribe consisted of three elements that were by no means mutually exclusive: peyote followers, church worshipers (who attended summer camps rather than dances), and powwow people. Even so, individual Comanches continued to maintain family and friendship ties, no matter what their group affiliation might be. With the war, many Comanche men left home to serve in the armed forces. Others left the region for defense jobs, since by now most younger Comanches spoke English. Before the war few jobs had been available. People had mostly sat around talking or playing cards or dominoes. But during the postwar years approximately one out of two Comanches left to find work elsewhere. In a physical sense the tribe had dispersed to a marked degree, a condition that persists today, with members returning periodically for family visits or to attend powwows, such as the annual Comanche Nation Fair.

Among those who remained, a subtle acculturation continued. Younger men who had achieved leadership roles in peyote circles during the decade before the war had emphasized the preexisting Christian symbolism in their ceremonies (which nevertheless retained the traditional, shamanic foundation common to all Comanche belief). This symbolism had also been filtering into dances and rituals since the Spanish era. As time went on, Comanches of all three groups were able to interchange more and more comfortably and frequently attended each others' gatherings. It should be emphasized that there never had been ideological schisms within the tribe; individuals wishing to do so had always moved freely between groups. In the postwar era, by far the most popular gatherings had become the powwows, with their dancing, feasting, gift giving, and honoring—all traditional ceremonies at which peyote people and church people could feel equally at ease while reaffirming with powwow leaders a common identity as a single nation with a unique history. Today powwows remain the most widely approved tribally sanctioned gatherings of the Comanche people.

The next-to-last landmark opened like a canyon of opportunity in time, red rock walls lined with juniper and piñon, with a stream winding far below. The year was 1966. In a referendum, Comanche tribal members voted to secede from the Business Council, which they believed to be dominated by the Kiowas and Apaches, who outnumbered them and apparently supported each other on intertribal issues. Three years later the Comanches formed the "Comanche Nation" and their own elected business committee, which is in reality a seven-person governing body. The committee supervises a staff working under a director in charge of practical tribal affairs, consisting principally of administering U.S. government programs and dispensing government funds.

As early as 1947 symbols along the trail implied an approach to the last great temporal landmark on this metaphorical path to the present. The first trail marker,

as well as those following, suggested that the United States Congress, as well as, presumably, the nation that had elected that body, possessed a conscience. The first sign was the establishment of the Indian Claims Commission. The Comanches, Kiowas, and Kiowa-Apaches had filed a claim in 1934 for the loss of their three-million-acre reservation. Eleven years after its creation, the Claims Commission awarded the three tribes a first and partial settlement of about $1.50 an acre.

Another sixteen years went by before the last landmark rose on the trail like a caprock escarpment before a pickup westering on the Southern Plains, when, in 1974, the Indian Claims Commission finally awarded the Comanche people, along with members of the other two tribes, a settlement of $35 million, to be divided proportionately according to tribal enrollments. The judgment was founded upon an examination (and repudiation) of the wily methods employed ninety-two years before by the Jerome Commission.

Nothing could replace the beautiful lost country, but the Indian Claims Commission—and by extension the U.S. government—had admitted, in effect, that an injustice had occurred. The payment was doubtless a mere fraction of the land's monetary value, but its symbolism was significant. Although the process had taken nearly a century, the Comanches and their former allies had received a measure of justice from a nation and a government toward which they could have, at best, ambivalent feelings. It was a moral victory for the Comanche people and was unfortunate only in that Wockneahtooah, Keithtahroco, Tissoyo and Yannyconny, Frank Moetah, the Komahs, Quanah Parker and his wives, and other members of the older and the interim generations were not alive to savor the admission and to see the attempt, made in apparent good faith, at reparation for a historical wrong.

ELEVEN

In the years, then, since 1875, have the Comanche people become acculturated? The answer must be yes, to a degree. They have adopted the English language to such an extent that the Comanche tongue is dying out, although efforts are being made to revive it through language classes for children. Many tribal members have converted to a Christianity whose symbols have permeated their ceremonies. Most adults drive cars or pickups, and they live, like other Americans, in houses, trailers, or mobile homes, rather than in tepees. Most have been to school, read and write, watch TV, and vote like other Americans. Many Comanche men have served in the armed forces of their country and are proud to have done so. Some have died for that country. Yet have the Comanche people *assimilated*?

Here the answer must be no. No tribal member forgets that he or she is Comanche. Each takes pride in belonging to the Nation, even if she or he lives and

works far from Oklahoma—as, for instance, a partner in an Albuquerque law firm. In spite of a century or so of strenuous efforts by the Indian Office and, later, the Bureau of Indian Affairs (B.I.A.) to destroy their culture, the Comanche people have maintained their identity as well as their individuality as a group with common traits, customs, and history. They have not assimilated—they have adapted to the degree necessary to protect and preserve that identity. By exercising their traditional eclecticism they have taken the elements they wanted from the dominant culture and rejected others. Fortunately, present widespread acceptance of the virtues of multiculturalism now defends them from the attempts at cultural destruction that the Indian Bureau formerly wreaked upon them. But they survived those, and having done so, the Comanche people today have reason to celebrate the maintenance of their tribal and cultural identity, which they do most notably at their annual Comanche Nation Fair.

This fair, really a powwow, derives from the parades and fairs of the late nineteenth and early twentieth centuries—and, of course, looking further back, to the traditional summer and winter tribal dances. After Buffalo Bill's Wild West Show began in 1883, mounted Indians were increasingly in demand as participants in parades and other outdoor spectacles. This was particularly true in some states of the former "Wild West." The historian William T. Hagan observes in his *United States–Comanche Relations* that during this period "no parade or other community celebration in the area was complete without its contingent of Indians in warbonnets and buckskins."

Quanah Parker, the Comanche celebrity, was especially sought after. In the early 1900s, Samuel "Burk" Burnett, the Texas cattle baron, persuaded Chief Parker for several years to lead parties of Indians to the Fort Worth Fat Stock Shows, where they staged parades through the city of Fort Worth. Quanah also joined his people to ride in parades during the Comanche County Fairs in Lawton, Oklahoma, near Fort Sill. But these fairs were still not the Comanches' own tribal celebration. After forming the Comanche Nation in 1969, the People initiated the Comanche Nation Fair, a festive gathering to which outsiders are welcome, but one which is principally a reunion as well as a triumphant celebration of tribal identity.

TWELVE

First you hear loudspeakers, peals of noise from the arena partly surrounded by low wooden bleachers with rows of folding powwow chairs placed between them. After parking under great shade trees, where Indian families camp or picnic near cooking fires, you traverse a bridge over Bear Creek and join a crowd moving at cross purposes but mostly toward the grassy circle within the stands. Even at the end of

September the Oklahoma sun is yellow and intense. Green leaves blot and scatter shadows on the autumn dust.

Dancers hurry by in bright regalia, men with bare brown arms, legs, chests, and painted faces, with feathers swaying and a rhythmic sound of bells. Women dancers swish by in fringed buckskin dresses. A few wear white dresses with red trim that have the image of a shield on their backs and the words "Comanche Little Ponies," the name of a traditional warriors' society. Another woman in a straw hat wears a red fringed shawl with letters in white on its back that read: Looking Glass Descendants, after a well-known nineteenth-century chief, Big Looking Glass. Young couples saunter hand in hand with children, while excited little girls rush with cups of Pepsi from the red-and-white truck where it is sold, nearly bumping into old men with canes.

At a distance behind the little grandstands, and surrounding the great circle they and the folding chairs create, are booths—staffed mostly by Indian men and women—where jewelry, coyote and fox furs and other peltry, T-shirts, novelties, and license plates with "Comanches: Lords of the Plains" printed on them are for sale. A booth attended by Shoshonis, the Comanches' Numic forebears, offers beautifully tanned buffalo rugs. A woman behind the counter, leaning forward eagerly, tells you, "Yes, we have our own herd."

It is late in the twentieth century, only a couple of years short of the millennium. You notice that the American flag, mounted on a slim pole before a tepee at the far end of the arena, is at half-mast and you wonder why. Later, talking with a tribal official, you learn that the next-to-last Comanche code-talker, Roderick Red Elk, has just died. He will be honored during the powwow. This same official, speaking with you and a Comanche friend, mentions that the turnout this Saturday is a little light. A number of families have gone to Medicine Lodge Creek in Kansas to meet with groups of Kiowas, Oklahoma Apaches, Arapahos, and Southern Cheyennes to celebrate the Medicine Lodge Treaty, signed there 120 years ago. "Celebrate?" murmurs the friend. "They ought to mourn it." The official goes on to explain that here, today, they will honor the remaining living "allottees"—that is, individuals who, most likely as children, received 160-acre allotments through the Jerome Agreement in 1900, or 120 acres provided by another bill in 1910. This ceremony takes place during the afternoon.

One by one families pass before the announcers' stand to receive for their aged relative a commemorative plaque and other gifts. All of the allottees are, of course, in their nineties or at least in their late eighties. Seventeen remain but many of these are absent, bedridden. Yet one frail woman wearing a plain dress walks forward without help, although accompanied by two younger women, to claim her plaque. Young women push an old man in a red cap forward in his wheelchair to claim his. Other women push a pale, white-haired woman forward, and a string of

a half-dozen relations falls in behind. Through the noise of the loudspeakers, the drumming, and the singing, you finally make out an allottee's name, in this instance, Hazel Yellow Wolf Codopony. Dances follow during the afternoon, as well as songs, including one named "Adobe Walls."

Much of the following afternoon is given over to honoring the Comanche code-talkers from the U.S. Army 4th Signal Corps, who served in Europe during World War II. The Navajo code-talkers, who served in the Pacific, are of course well known to journalists and have received deserved recognition. But the Comanche code-talkers remain virtually unknown to the American public, even though their language code—for example, *wakaree?*, or "turtle" for "tank"—was never broken by the German Army. In 1989 the French government awarded them the French National Order of Merit for outstanding and meritorious services during the D-day invasion of France from June 6, 1944, to September 1944.

Now, fifty-three years later, at the end of another September, a code-talkers' song is sung and a code-talkers' dance is danced. These are followed by the scalp dance, a victory dance restricted to women. Rarely performed, it is now given in these veterans' honor, with several of the leading women carrying symbolic lances, advancing, turning, and retreating in a line before the announcers' stand. The women, most wearing colorful shawls, proceed into the buffalo dance, constantly moving as if in a herd, until with a change in the tempo of the drums, they turn with a slight jump from side to side. This is followed by the horse-stealing, or hoof, dance, in which the dancers peer around at the ground as if looking for tracks, straightening at a change in the tempo of the drumming, and alternating their feet in a kicking motion. The women, now joined by the men, conclude with the round dance.

Finally, after describing the horrors of the American landing on Omaha Beach, the bodies of young men floating near shore, an emcee introduces Charles Chibitty, the last living Comanche code-talker, who, with a pretty little granddaughter standing beside him, utters his thoughts, speaking about his late comrade Roderick "Dick" Red Elk and warning about the destruction of modern warfare. The honoring ends with Comanche veterans and others falling in behind Chibitty and shuffling around the circle to the pounding of the drummers and the lusty cries of the singers. From around the arena women and men, including this writer, walk out singly and shake Chibitty's hand. The Comanche warrior tradition remains alive, whether the individual warrior happens to be known as "Ten Bears" or simply as "Charles."

Meanwhile, a hundred yards south in a grove of large trees, singing and drumming continue. Here in the shade, seated on benches, two groups of four to six individuals, men and women, face each other, one side drumming and singing while a person from the other side, standing, scrutinizes them. Suddenly she points triumphantly. Spectators laugh. She has identified the man on the opposing team who has been holding the little bone object, worn smooth as ivory, and the hand

within which he has been holding it. Her team receives one of the sticks used as counters. This is the "hand game" or the "stick game," a gambling game whose origins go back at least to the Comanches' early nomadic life on the Southern Plains.

Gladys Narcomey, a Comanche woman, recalls that more recently, when she was a girl, the hand game was played only in winter. She remembers frosty evenings in a canvas tent with a wood stove when the game sometimes continued all night. At Christmas, she recalls, the winners of the first game would present all the players with fruit, including apples and oranges.

Now an announcer, speaking from his platform at the circle's edge, reiterates declarations of the Comanche Nation's pride in *all* its veterans, who have "protected our country." Later, as a new column disperses, he introduces a middle-aged couple who came all the way from France. Still later, entertaining the crowd, he jokes about his own stature: "I even had to stand on a chair to kiss a beauty queen." Here and there men gather, talking, or sit in folding chairs and chat in the shade of pickups with camper shells. Many wear blue jeans and boots, bright shirts, cowboy hats. Older women sit in colorful rows talking with each other or with darting grandchildren who pause briefly. Young men and women not dancing wear jeans and T-shirts. No alcohol is sold here, nor is there any evidence of drinking. This is a family, as well as a tribal, celebration. Everyone is carefully dressed, cheerful, mannerly, in a holiday mood.

You wander farther around the circle, pausing to ask three older men dressed in quills and feathers and wearing hairpipe breastplates if you may take their picture:

"Sure," says one. "We take Visa." Laughter. You click the camera.

A drum sounds from the circle's center with its cluster of drummers and singers. The loudspeaker announces a gourd dance, and a line of brightly attired men—one with half his face painted yellow, the other half black—begins to shuffle around the arena. People turn. Some stop talking to look. One of the dancers gives out a loud war whoop, the high, piercing vibrato ululation of long ago shocking the present for seconds into the past, when this was the American "Far West," long before Lewis and Clark, Sam Houston, or Buffalo Bill . . .

Those who have called themselves the Nuhmuhnuh for some three hundred years continue to celebrate their identity—as Americans, yes, and beyond that, as a people justifiably proud still to be known to the world as "Comanches," the people who were, not so long ago, "Lords of the South Plains."

A Note on the Photography

In May of 1996 a Valuejet DC-9 carrying over a hundred passengers and crew members plunged into the Florida Everglades. The jet exploded on impact, killing all on board. Weeks afterward workers were still wading through the muck of the swamp in their search for fragments of the aircraft, as well as for body parts of the dead. The task was so demanding that these men worked in short shifts, each group relieving another every few hours. But, according to a network TV news broadcast, it was neither the immersion nor the risk from poisonous snakes or alligators that provided a moment of maximum stress to one man. This moment came when he plucked a family album from the slime. Glancing through soggy photos of unknown children, men, women, and infants of various ages, he thought of his own family. The realization of the magnitude of the loss in human terms struck him with such poignancy that he remained for a time unable to carry on with his work.

Such is the evocative power, in some contexts, of ordinary photographs. The critic Susan Sontag, writing of photography twenty years ago, pointed out that all photographs contain an element of pathos because they are, in effect, specimens of life sliced and mounted on a slide, slim portions of that time—the medium in which we live—that is ceaselessly passing. Because of the irresistible passage of time, the pathos inherent in photographs augments as they age, until even pictures snapped by careless amateurs may achieve the level of art.

The photographs in the following pages, however, were not shot by careless amateurs. In addition, they have a further claim to pathos beyond that of the individual faces and figures recorded on the "slides" of glass plate negatives exposed in the Oklahoma-Texas Red River region approximately between 1895 and 1908. They also record the immediate aftermath of a former way of life, the Comanche people's free and nomadic existence on the Southern Plains circa 1700 to 1875. Viewed in that respect, they are charged with a sense of loss and, beyond that, of history as well.

Unfortunately we know relatively little about the photographers themselves. We do know that Lon Kelley and Alice Snearly lived in Henrietta, Texas. Both

their families were established in the community, Albert Snearly's since 1877, when he arrived with his wife and three daughters, Grace, Gertrude, and the child they nicknamed "Lady Alice." Some years later the families became partners in a general store—Kelley, Conn, and Snearly. Alice's uncle, Norman "Pete" Snearly, owned and managed Henrietta's St. Elmo Hotel. As a young man, Kelley became a professional photographer, although he later assisted his brothers-in-law with the store, ultimately serving as clerk of Clay County for fifteen years. He was married to Alice's sister Gertrude. Alice, an intelligent and attractive young woman, apparently developed a keen interest in photography, perhaps under the influence of her brother-in-law. She became his assistant and student in photography.

Next it appears that in about the mid-1890s Lon, Gertrude, and Alice moved temporarily to Duncan, Oklahoma, an Indian Territory railroad town north of Henrietta and some thirty miles east of Fort Sill, perhaps traveling by wagon with their baggage and gear. There Kelley installed his photography equipment in a studio previously occupied by another photographer. This equipment must have included at least dry-plate (presensitized) glass negatives, light-reflecting panels, a special lantern for illuminating interior scenes—or, as an alternative, the hand-held trough designed to contain magnesium flash powder—and props, such as a wicker chair, animal skins, and, especially, the painted canvas backdrop visible in all of the studio portraits. At any rate, we do know that Lon, Alice, and Gertrude are recorded in the 1900–1901 census as residents of Duncan, with Kelley's profession listed as "photographer" and Alice's as "artist."

"Artist" in this context has a special significance. Enlargements during the period were made by projecting, using a kerosene lantern, an enlarged image upon a screen consisting of sensitized watercolor paper. The artist would then trace and sketch, perhaps with charcoal, a likeness of the duplicate. The final result would be an "enlargement" of the photograph. But Alice doubtless learned a good deal more about photography than how to enlarge photos from her brother-in-law over the five or six years that she and her sister seem to have resided with him in Duncan.

It is, of course, impossible to know which, if any, of the following pictures can be attributed to Kelley and which to Snearly. On the Fort Sill Museum accession sheet for the Ben Fish Photo Collection, the former director, Gillette Griswold, wrote in about 1961: "Photos taken by Miss Alice Snearly, pioneer Henrietta, Texas, photographer, during period c. 1898–1908 . . ." In addition, Griswold scrawled in ink under the description of virtually every image "Snearly photo," and by some of them, "c. 1900." While Griswold's attributing the photographs exclusively to Snearly does not make a conclusive case for Alice as the sole photographer, it does suggest the probability that she shot many, if not all, of the photos in the Ben Fish Collection. That collection includes most of the images to be seen in the following pages. (There are two exceptions, the image of Quanah Parker posing with his two wives,

shot by W. E. Irwin, and that of Geronimo with revolver, which was taken by George Long.)

Ben Fish was a retired oil-field worker. A friend of his acquired the collection of glass plate negatives for two bits (25 cents) at an auction in Henrietta in 1961. He gave them to Fish, a resident of Iowa Park, Texas, who showed them to the editors of the Times Publishing Company at Wichita Falls. Realizing their historical value, the publishers of the *Wichita Falls Daily Times* and the *Wichita Falls Record News* developed prints, apparently featuring them in their Sunday magazine. They gave duplicates to the Fort Sill Museum, hence the museum's "Ben Fish Collection."

After the death of Fish in 1963, Dale Terry, of Wichita Falls, acquired the entire collection of glass plate negatives. In the early 1990s, Terry sold the negatives to the novelist Larry McMurtry, who in turn presented them to the University of Texas Press. Terry believed, and believes, that "the glass plates were exposed in the 1890s to about 1905 by Alice Snearly and Lon Kelley" of Henrietta. Somehow, however, Gillette Griswold, director of the Fort Sill Museum in 1961, became convinced that the entire series of photographs had been shot by Alice Snearly.

So where does that leave Lon Kelley? Future inquiry may reveal his part, if any, in the collection. For the present it remains problematic. Can we assume that he took at least the picture of Alice with the Comanche man named Piah Kiowa? Probably. We do know that sometime in or around 1901 Kelley returned from Duncan to Henrietta and opened another photography studio on the ground floor of the recently vacated Clay County jail. We also know, sad to state, that "Lady Alice" Snearly died in 1908 at the age of thirty-two.

It's unfortunate that we can only speculate upon Alice Snearly's motives for undertaking the series of studio portraits. Was her motive, like Kelley's, principally commercial? We may assume that the spirit of the time—an acute awareness of the frontier's passing—had created a market for such pictures, so it is possible. Was it artistic, at least in part? The fact that she was the "artist" in her partnership with Lon suggests the likely possibility of a sensibility that demanded more from her than just tracing images upon a screen. Could it have been a response to the historical impulse to record that which was certain to be gone in a not distant future? This also seems likely. In any event, we may suspect that her motives—and perhaps even Kelley's—contained an appreciable quantity of nostalgia, since nostalgia was a principal ingredient of the *Zeitgeist* during the decades before and after the turn of the century.

Kelley and Snearly were not alone in possessing what seems to have been a longing to record the recent past. From the time of the organization of Oklahoma Territory in 1890 to the turn of the century, a number of photographers operated in the region. Actually there were sixteen hundred photographers in Oklahoma before 1920, many of them women in the later years. Since there was much recopying,

a viewer cannot even depend entirely upon the name of the photographer in identifying plates or prints. Lon Kelley, for example, while in Duncan, sold under his name images taken by other photographers, such as Irwin, evidently a common, though less than reputable, practice at the time. To add to the confusion, some enterprising individuals out of Kansas pretended to be the "Only Government Licensed Photographers" authorized to take pictures of Indians. Others entered the territory from Texas. Some of these people worked out of tents or even railroad cars. Later, between 1910 and 1915, the motives of many of them became obvious: they were printing and selling picture postcards, and those depicting Indians, "the vanishing American," were particularly popular. One photographer, Edward S. Curtis, who was to become well known and whose range was generally more northward and westward than Oklahoma, and whose goals were more idealistic than those of the hacks, based an entire career on documenting this so-called vanishing American.

Not only historians but westerners in general were aware of the passing of the frontier—the disappearance of the buffalo, the arrival and multiplication of railroads, the defeat of the Plains Indians and their confinement upon reservations. This triumph of "progress" brought with it a concomitant sense of loss, particularly to people who were living in regions where those events had occurred. They realized they had been living in the midst of history in the making. Because of this, the figure of the Plains Indian warrior in particular became invested with nostalgia. He became a living symbol of the recent past, one for whom it was now easy to feel sympathy, an icon of nostalgia. Charlie Russell, the cowboy artist, wrote his friend E. C. ("Teddy Blue") Abbott in 1919 from Montana, where they both lived, lamenting the disappearance of the frontier and affirming their mutual feeling of identity, as old cowpokes, with the Plains Indian:

> I remember one day we were looking at buffalo carcus and you said Russ I wish I was a Sioux Injun a hundred years ago and I said me to Ted thairs a pair of us
>
> I have often made that wish since an if the buffalo would come back tomorrow I wouldent be slow shedding to a brich clout and youd trade that three duce ranch for a buffalo hoss and a pair ear rings like many I know, your all Injun under the hide and its a sinch you wouldent get home sick in a skin lodge
>
> Old Ma Nature was kind to her red children and the old time cow puncher was her adopted son . . .
>
> *Your friend*
> C M RUSSELL

Lon Kelley and Alice Snearly were hardly old buckaroos, but they could not have been immune to the mood of the times. No historians either, but individuals living in an era and region where rapid historic change was taking place, they had in their hands the perfect instrument for recording images of an interim generation of Comanche men and their families who were about to lose—or had just lost—their vast reservation and who would be compelled to live lives a great deal more like those of other rural Americans. The unique and "colorful" aspect of those lives, the photographers must have surmised, would soon disappear. It is not unreasonable to speculate that Alice, at least, responded to a sense of urgency and set out to record what she could of the Comanche past while it still lingered on the features and in the dress of that generation whose parents and forebears had roamed the Southern Plains, following the buffalo.

Kelley and Snearly, it would seem, approached their subjects with sensitivity and respect. The most striking manifestation of that intent is the portrait of Lon and the Comanche man named Piah Kiowa. It is the only image we have of Kelley, although the other man appears twice more, posing with Alice and with her sister Gertrude. Kelley and Piah Kiowa are shown holding hands in a pose suggesting both equality and friendship. For their parts, Alice and Gertrude wear in their portraits mild expressions. With Alice, Piah Kiowa faces the camera composedly, but with Gertrude, he rears stiffly back in the wicker chair, as if she were a stranger to him. In the remainder of the portraits, most of the photographers' adult subjects regard the camera calmly, self-possessed, with intrinsic dignity.

It is interesting to compare Snearly's portraits with those of Adam Clark Vroman, who (in *Dwellers at the Source*, by Webb and Weinstein) was photographing Southwestern Indians—Hopis, Zuñis, Pueblos, and a very few Navajos—about the same time, between 1895 and 1904. Susan Sontag, in 1977, found Vroman's handsome images "unexpressive, uncondescending, unsentimental." Snearly's work was also unsentimental and uncondescending. But some of her photographs were far from "unexpressive." The difference may lie in the people photographed. Except for the Navajos, none of the Indian tribes whose images Vroman recorded was a warrior people.

The Comanches, who call themselves the Nʉmʉnʉʉ (Nuhmuhnuh), "People," had been daring horsemen, buffalo hunters, fighters, predators. Older Comanche men still considered themselves to be hunters and warriors. It was an integral part of their identity. You see it in Quanah Parker's proud stare, see it even in his wives' fierce scrutiny. You see pride and defiance on the features of Muvecotchy and in Paaduhhuhyahquetop's look of indignation. You see it, too, in Frank Moetah's intense, unyielding gaze, and in Tissoyo's glare at the camera. Some of the portraits of the older Comanche men were indeed "expressive" and in that respect not comparable to those of the Indian men portrayed by Vroman.

In fact, they stand in contrast to those images. They may be compared more appropriately to photos of Blackfeet men taken by various photographers between 1882 and 1945 in William E. Farr's collection—especially, for example, to Jack Big Moon, Shortie White Grass, Four Horns, and The Coat, whose photo, with his features set in a defiant and scornful expression, provides the cover for *The Reservation Blackfeet, 1882–1945*. The Blackfeet were, of course, also a warrior people, and some of the photographs of their men are equally as expressive as those of some of the older Comanche men.

One does not wish, of course, to reinforce cultural stereotypes. Nevertheless, it is a fact that there were profound cultural differences between the Southwestern peoples (again, excepting the Navajos) and the warrior nomads of the Great Plains. There are differences as well between many—perhaps a majority—of the studio portraits taken of Plains Indians during the late nineteenth to early twentieth centuries and Snearly's images. Although few of the former possess the evocative quality and beauty of Edward S. Curtis's "gold-toned," soft-focused "romantic" images, many of the subjects also appear to have been posed according to the photographer's purpose, as Curtis posed his Native Americans, even persuading some of them to wear wigs and paying others to shave off their "inauthentic" mustaches.

While the portraits are not costumed and "staged," the posed subjects frequently give the impression of waiting resignedly to be done with an unpleasant obligation not of their own choosing. Such is the case, for example, with a seated portrait of the Sioux chief Red Cloud, taken by Charles Milton Bell in 1880 (in *Native American Portraits 1862–1918*, by Nancy Hathaway). The chief, with a feather in his hair and dressed in a fringed buckskin shirt, holds a staff across his lap and, in an apparent reverie, stares into space. It is clear that he would rather be somewhere else.

Exceptions to images of patient, bored warriors are provided, however, by the sharply focused photographs of William S. Soule (collected in *Plains Indian Raiders*, by Wilbur S. Nye). Soule took them between 1867 and 1875 at Fort Dodge, Camp Supply, and Fort Sill, long before Alice Snearly took her portraits. Yet perhaps the attitude of the subject was at least partly dependent upon a good interrelation with the photographer. Both photographers seem to have established a rapport with their subjects. Soule took many excellent pictures of the older generation of warriors sequestered on their reservation. Such leaders as the Kiowa Satanta and the Comanche Horseback, who both signed the Medicine Lodge Treaty, regard the camera with alert, searching expressions.

Alice Snearly's Indian subjects, members of the following generation, seem also to engage the camera—or the woman photographer behind it—frankly and willingly, with but two exceptions: Old Man Komah, who seems momentarily distracted; and Muvecotchy, apparently self-absorbed in a theatrical pose. Of Soule's Comanche photos, a possible exception is that of Mowway, another headman who

signed the treaty. Mowway gazes to the side, apparently receptive to the portraiture but distant in thought or memory. Yet this is a striking portrait of the war chief, who was the father of Tissoyo and Yannyconny shown in Snearly's prints.

Snearly's outdoor photographs are simpler to discuss. They depict the Comanche people in a proper context, both temporal and spatial. The mounted cowboys, with cattle in the background; the little Comanche girl sitting on her pinto before a wagon; Indian horsemen at the Cache issue station; the gathering of Apache and Comanche horsemen beside the Fort Sill cavalry barracks, seemingly spellbound by the demonstration of a kerosene lamp; the Indian parade forming on Henrietta Square; the general store and settler's house; even (after 1901) the steam oil rig at Petrolia, Texas—all of these were, or would soon become, part of the background of the People's lives, like the wagons that had replaced the travois, like the steam locomotives and railroads, with their variety of exotic sights, smells, and sounds.

But there is an intriguing incongruity contained within the studio portraits. It inheres in a single prop, the painted canvas backdrop that appears to various degrees in all the portraits. What are these representatives of a defeated pastoral, warrior people doing posing before what appears to be a Victorian garden with Grecian columns? Is placing them there an unconscious impulse toward "instant civilization"? Well, probably not. No doubt the juxtaposition was accidental, not intentionally ironic. In all likelihood Kelley owned but a single backdrop, with a scene standard for the late nineteenth century, which he and Alice used for all of their subjects, Anglo or Indian. But accidents may prove serendipitous and revelatory.

The columns, drapes, floral patterns, and the iron-fenced garden, with its stone stairway leading back perhaps to lawn and vague trees—these could hardly be more out of keeping with the Comanche subjects, dressed mostly in modified versions of their native attire, ornamented with brass beads and feathers, their feet in moccasins or horseman's boots and placed upon the dried pelt of a fox or coyote, or even upon a bearskin rug. Past, present, and future mingle here. The painted canvas lends an air of the fabulous, surely unintended, to these portraits.

The flimsy, rain-stained backdrop poses questions to the viewer's imagination that Kelley and Snearly probably never conceived of. The imagination inquires as to what lies beyond the garden and trees—high plains, maybe, where antelope and herds of buffalo graze under an endless sky? It does not take the apparition of an angel with a flaming sword standing upon that stairway to suggest a time and place from which the people in the foreground have been forever banished.

Yet there were compensations, consolations. The Comanches had been an adaptable people since splitting off from the Shoshonis in the Rocky Mountains of present-day Wyoming to venture out on horseback into the bison-rich Great Plains in the seventeenth century. Keeping no records except for occasional rock art, they

habitually turned their backs on the past. David G. Burnet, first president of the Republic of Texas, who spent about a year among the Texas Comanches, wrote of them in a letter dated "August 1818" that "careless of the future, they are indifferent to the benefits that accrue from the recollections of the past. The revolving day imbodies [sic] all their concerns."

It appears that Burnet, who was no ethnologist, unwittingly exaggerated. The Comanches were not a simple, uncomplicated people, in their religious beliefs or otherwise, contrary to one stereotype. But the historical Comanches did believe in living in the present. To an extent the People still do, in contrast, for example, to a group like the Amish. An attitude prevalent among the Nuhmuhnuh today might be expressed as "Honor the past, but don't get mired there. Live here and now." Bumper stickers read "Comanches: Lords of the South Plains," but they are bumper stickers and they appear on cars and pickups, often shiny new ones.

If we review the Comanche portraits in the present volume, we find no one who appears cowed or demoralized. All of the men and nearly all of the women regard us with self-assurance. If they, as Comanches, had lost a great deal, they had also made sufficient gains so that the future surely did not appear intolerable to them. Eclectic as always, they had adapted to the degree they wished, taking what they wanted from Anglo culture and rejecting aspects they did not want—except when, as with boarding schools for their children, a specific change was forced upon them.

Much against their wills, they had exchanged their former freedom as nomadic raiders for a certain amount of security. It was not a fair trade, but they made the best of it. Finally no longer hungry, they could count on three meals a day. There was beef, often now from their own small herds of cattle, and the sugar and coffee they had relished since first contact. Some families had a roof, which they had formerly despised, over their heads instead of their recent canvas tepee. They still had recourse to their own medicine people, but they could also visit a government physician, and many used both.

They had lost their great pony herds and the travois in which they had transported their parfleches and other belongings, but they still had horses to ride and the wagons that had replaced those travois, which they could drive to the Cache store on each issue day. Both the peyote fans and the strings of mescal beans seen in several portraits indicate that the communal and spiritual needs of many were being satisfied, while increasing numbers of families had fully converted to Christianity and were gathering with other Comanches in the "medicine home" of their own choosing. Best of all, despite outside efforts to detribalize them, and their own endemic factionalism, the Comanches had remained a tribe, a single people whose culture, though frequently modified, had endured and would, as they would, continue to endure.

If we examine the accompanying photographs carefully, we find evidence of the Comanches' eclecticism and, to a certain degree, of their adaptation. First, a caution, however. Neither the wearing of Anglo clothing nor being photographed with white companions necessarily indicates adaptation to Euro-American culture. If eighteenth-century Comanche warriors wore pieces of Spanish armor when they could get them, and used Spanish swords for their lance points, nineteenth-century Comanche men sported articles of Anglo clothing that appealed to them, especially U.S. Army officers' jackets, while their women carried parasols when they, in turn, could obtain these sunshades.

Furthermore, Daniel J. Gelo has remarked upon trade words from Spanish that entered the Comanche vocabulary in the eighteenth century—such words as *póro* for *barra* (iron bar), *supereyos* for *sombrero*. In the nineteenth century, Comanche words for items such as "bead" and "red paint" took on new meanings when commercial beads, vermilion, and similar trade goods became available. These words had no basis in the English language, but the People enlarged their original meanings to include objects that they wished to obtain through barter. (There is one amusing exception: the Comanche word *pínica* derives from English to designate—of all things—"petticoat.") This does not mean that the Comanches unreservedly accepted either Spanish or Anglo-American culture, although they were surely influenced by aspects of each.

The photos in this book exhibit a variety of clothing combinations, but in nearly every one portraying a man or men, an American "Western" style is present or predominates. An exception is the portrait of Frank Moetah, Quanah Parker's rival. Moetah wears a suit, with white shirt, tie and stickpin, and vest with (apparently) a gold watch chain. Only his neatly tied braids and his earrings are concessions to Indian tradition. Quanah himself, shown with his two wives in a formal pose, is dressed traditionally, wearing moccasins and a blanket, his braids wrapped in otter skin. Yet there is—though not included in the present collection—at least one photograph of him dressed, like Moetah, in a suit. At the other extreme is Wockneah-tooah, splendidly Comanche in his ornate peyote regalia, yet he wears the ubiquitous scarf in such a manner that it resembles the necktie worn, for instance, by Anglo shopkeepers. Most of the other males depicted in this book dress in a mélange of Anglo and Indian styles.

The jackets, vests, shirts, and pants of these men appear to have been manufactured. Some few men, like Piah Kiowa with both Kelleys or Keithtahroco or Muvecotchy or Wockneahtooah, wear moccasins. The majority wear horseman's boots, while Pauchee, following this theme, dangles a quirt from his wrist. (With Alice, Piah Kiowa wears not only boots but leather gloves and topcoat, along with neckerchief.) The scarf or neckerchief worn by nearly all the Indian men not only added a bright patch of color to their attire but could serve practical uses as well. In

fact the bandanna may have been borrowed from the trail and ranch cowboys, who used it to protect their necks from the sun and, especially, to tie across their faces against the dust when driving herds of cattle. The broad-brimmed Western hat worn by many of the Comanche men was also a practical shield against sun, rain, blizzards, and other varieties of intense Plains weather. It, too, may have been borrowed from the trail or ranch hand, and not merely for utilitarian reasons.

As the popularity of Buffalo Bill Cody's Wild West shows spread, the public began to see the cowboy, along with the Plains Indian, as a figure of romance. Knowledge of this attitude surely spread among western Indians, especially among former "horse Indians" whose tribal members were employed by the shows. By 1900 the Wild West shows were entering the period of their greatest popularity. According to the historian L. G. Moses, a Yankton Sioux named Harry Lucas wrote the Miller brothers of the 101 Ranch Real Wild West in 1911 that he had enjoyed show life the previous year and wished to know whether he could return "as a cowboy & my wife a cowgirl when I come back." He and his wife were granted their wishes and employed for that season as Indian cowboy and cowgirl.

In addition, *The Great Train Robbery*, the first Western film of any length, was made in 1903, a year after the publication of Owen Wister's landmark novel *The Virginian*. A perception of the cowboy as a charismatic figure was increasingly in the air. In 1908, the year of Alice's untimely death, the Oklahoma Mutoscene Company filmed a Western called *The Bank Robbery* on location in and around Cache itself, and even employed Quanah to fill a bit part. Surely Comanche families must have discussed the event with amusement and pleasure, chuckling puzzled opinions concerning pretended lawmen galloping after pretended outlaws, each group outfitted in ten-gallon hats.

Might the newly popular attitude of admiration toward cowboys, dating from the Wild West shows, have contributed to the frequent selection of the Western hat among Comanche and other Indian men? Or was the appeal merely practical? Who knows. Yet it is possible that the "romance" associated with the cowboy hat may have increased the allure of that utilitarian sombrero for Comanche men. As we may judge from the photographs in this book, Comanche men clearly selected from the ready-made Anglo clothing available to them those garments they wished, and combined them to create effects of their own choosing. Was this adapting to Anglo culture? To a degree, yes.

The same may be said for the women. They dressed modestly, probably in bright colors. Blouses, blankets, shawls, and moccasins appear to constitute the basis of their apparel. For example, Quanah's wives wear long-sleeved shirts and are either holding fringed blankets or have wrapped them around their bodies from about the waist down. Esadooah, shown with her policeman companion, appears to be wearing a silk jacket over a patterned dress, with a fringed blanket and perhaps a

shawl, too, over her knees. Below her skirt she wears ornamental leggings and moccasins. While the materials are Anglo, the effect is clearly Indian.

The two Kiowa girls with Deputy Bud Ballew are wearing dresses, with a fringed blanket draped over one or both shoulders. Scarves with large floral patterns cover their laps. From beneath Amy's skirt protrudes a store-bought shoe, while Carrie holds a peyote fan and wears earrings shaped as crosses. Utah, or Blanche, shown with her father, Paaduhhuhyahquetop, and siblings, is dressed much like Esadooah, Indian style. The two women shown in the group photo with Pete Snearly, Tissoyo, and Yannyconny are wrapped in blankets, as is Yannyconny herself. The little Comanche girl, like the little white girl, wears a dress. Again, while the materials of these women's apparel are manufactured and Anglo, their arrangement and style, except in the instances of small children, are Indian.

We can conclude that the Comanches' use of Anglo items of clothing is not necessarily an indication of their complete adaptation to Anglo culture. Nor can we assume that their being photographed with Anglos indicates assimilation either. The Comanches portrayed here in the photographs almost surely had *some* Anglo acquaintances and friends, probably including most or all of the whites depicted with them. But the individual Native Americans and Anglos shown in these photos may have been exceptions to the general rule. As the anthropologist Morris W. Foster has observed (in *Being Comanche*), there is, even today in southwestern Oklahoma, "an unspoken barrier to recognizing [Comanche individuals] as equally privileged members of the Anglo-dominated community." Elsewhere, Foster has remarked that in Comanche business council meetings held nowadays, "an acceptable excuse for the failure of a tribal program is that Anglos have in some way tricked, or gotten the better of, an elected official. This plays on the sympathy of the audience, all of whom have been taken advantage of in Comanche-Anglo interaction at some point." Foster's observations suggest that approximately a hundred years after Alice Snearly took the photos in this collection, a gap remains, slight or otherwise, between the Comanche people and a majority of their Anglo neighbors.

On the other hand, there is something unusual about these portraits. The viewer may detect it in the subjects' expressions, their mien and bearing, which reveal their attitudes. While all interpretations of photographs are necessarily subjective and impressionistic, there is a sense here that the individuals portrayed, especially the Indians, are not just passive models, to be manipulated and posed according to the photographer's purpose—as the photographer George Long (not Snearly) posed the Apache Geronimo, in Plains warbonnet and war shirt, with revolver. Rather there is a sense that these people have "come to have their pictures taken" for purposes of their own. Attempting to stare through the fog of the past, we can only speculate as to their purposes. Perhaps, during that period, being photographed

was a novel, popular, and mildly prestigious act. Or perhaps the pictures were taken to reinforce kinship ties.

Towana Spivey, director of the Fort Sill Historical Museum, observes that Indian families as well as Anglo ones did buy and preserve photographs. Perhaps these images were intended to take their place in a Comanche equivalent of the Anglo family album. Furthermore, it is interesting to note that, when photographed with Anglos, the Native Americans (except for Piah Kiowa with Gertrude Kelley) appear to feel at ease with and equal to their companion or companions. These people were clearly acquaintances. Were they friends? In some instances—such as that of Piah Kiowa and Kelley or of Tobin Worksu and the smiling young lady, or of Pete Snearly, Alice's uncle, whose hand rests on Tissoyo's shoulder—they probably were. Quite possibly other friendships existed among those being photographed, including friendship with Alice. Consequently, to the extent that friendly feelings existed between the Indian subjects of the portraits and the Anglos shown with them, the Comanche individuals had adjusted to Euro-American culture by a shift in attitude, no matter how slight. And, of course, the Anglos had adjusted, too, in setting aside their old prejudices.

Snearly's Indian subjects appear to be presenting themselves as exactly who they are—Comanche people (except for Geronimo and the Kiowa girls, who had their own tribal allegiances) poised in time, attesting, maybe, to their survival as individuals belonging to a nation with a culture at once traditional and in the process of evolving—as always, on its own terms. In spite of their tribal losses, the Comanche individuals portrayed in the following photographs had remained Nuhmuhnuh in the most important sense. That awareness of who they were manifests itself in the images recorded by—possibly—Lon Kelley and by, almost surely, his former student in photography, "Lady Alice" Snearly.

The Photographs

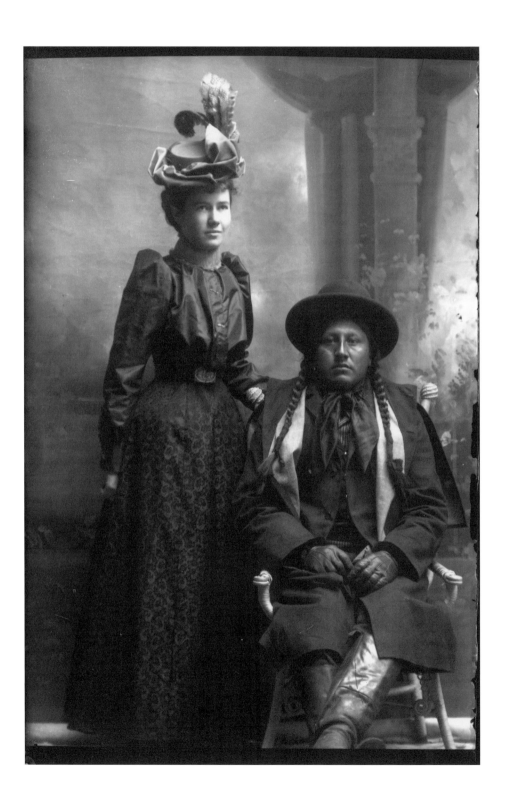

Piah Kiowa with "Lady Alice" Snearly

The photo shows a Comanche man named Piah (or "Big") Kiowa. He was married to Perkaquanard's sister, Tabbymachi, and had a brother named Quidervitty. He was apparently a friend of the photographers, Lon Kelley and Alice Snearly. One or the other photographed him with Kelley's wife, Alice's sister Gertrude, as well as with the other photographer. Here he poses with Alice, whose parents bestowed upon her the nickname of "Lady Alice." Alice was one year old when she came with her parents in 1877 to settle in Clay County, Texas. She had, besides Gertrude, another sister, Grace.

Is it possible her family found her a little "highfalutin"? We may speculate that perhaps she possessed an acute sensibility that distinguished her from Grace and Gertrude. Because of a difference in her behavior from that of the rest of the family, her parents and sisters may teasingly have begun calling her "Lady Alice." Her being perhaps a little "different" could explain why she, of the three sisters, became interested in photography, and even why she became an artist in her work with Kelley, tracing images cast upon a screen in order to create enlargements. Was this pioneer woman photographer also an artist in photography? That remains for the viewer to judge.

Regarding Piah Kiowa's unusual (to Anglo ears) name, and Indian names in general, it is interesting to note that some Plains Indian men and women bore the name of their own or another tribe, or conceivably even another race. For example, there was a Kiowa-Apache called Apache John (really Goñkoñ, or "Stays-in-Tepee"), as well as the woman named Utah in Photo 8, who was not a Ute but a Comanche. There was, in addition, another Kiowa-Apache leader named White Man (Tsáyadítlti), who sometimes accompanied Quanah Parker on his trips to Washington.

Daniel Gelo points out, however, that "White Man" is not necessarily a reference to another race, since names referring to a person's whiteness, or brightness, might signify an attribute of "chiefliness" or an aura of spiritual radiance and were common in that context. In fact, he notes that versions of the Comanche word *taibo*, now meaning "white man," has variously meant "sun person," "chief," "easterner," "Anglo," "Frenchman," and "captive" in the Shoshonean languages.

Quanah Parker with Other Comanche Horsemen

The photo shows Quanah Parker, along with other Comanche horsemen, in a field, dressed in their regalia, apparently waiting for a ceremony. Shields such as those carried by the two near horsemen are rarely seen in pictures taken during this period. A copy of this photograph mounted in an album possessed by Louise Womack of Henrietta, Texas, carries the following inscription: "Black Horse, Comanchete [*sic*], and Quanah Parker at a war dance, November 1899." Apparently such gatherings were often held north of Henrietta, and close enough so that townspeople could hear the drumming.

Black Horse was a Kwahada chief who, while on a buffalo hunt in 1878, was attacked by seven Texas Rangers. Later, after the initial skirmish, he and his twenty-five warriors ambushed their adversaries, killing at least one and wounding two others. Thus, by accident, he led the last Comanche fight in Texas.

Towana Spivey, director of the Fort Sill Museum, relates an amusing anecdote with regard to Quanah, the war chief's followers, and the Fort Sill Apaches. In 1898, during the Spanish-American War, only a single troop of cavalry, under the command of a lieutenant, remained at the post. A rumor began circulating that the Chiricahua Apaches were planning to attack and take over the fort. The lieutenant panicked and telegraphed for help. Before troops could arrive, Quanah rode to headquarters leading his private militia of Comanche warriors and offered his support in defending the post. His assistance, however, was not required. The post trader, returning from a trip, discovered that the Apaches had formed no such plan and were chuckling among themselves over the furor. But Geronimo, who was simultaneously a prisoner of war and a U.S. Army scout, had hurt feelings, according to Col. W. S. Nye (in *Carbine and Lance*), and replied to interrogators, "I'm a U.S. soldier. I wear the uniform, and it makes my heart sore to be suspected."

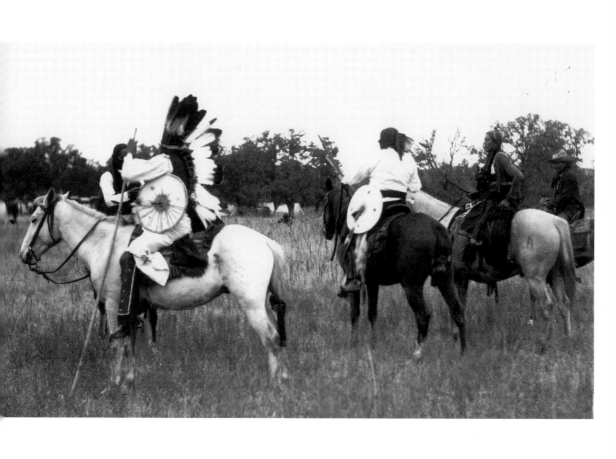

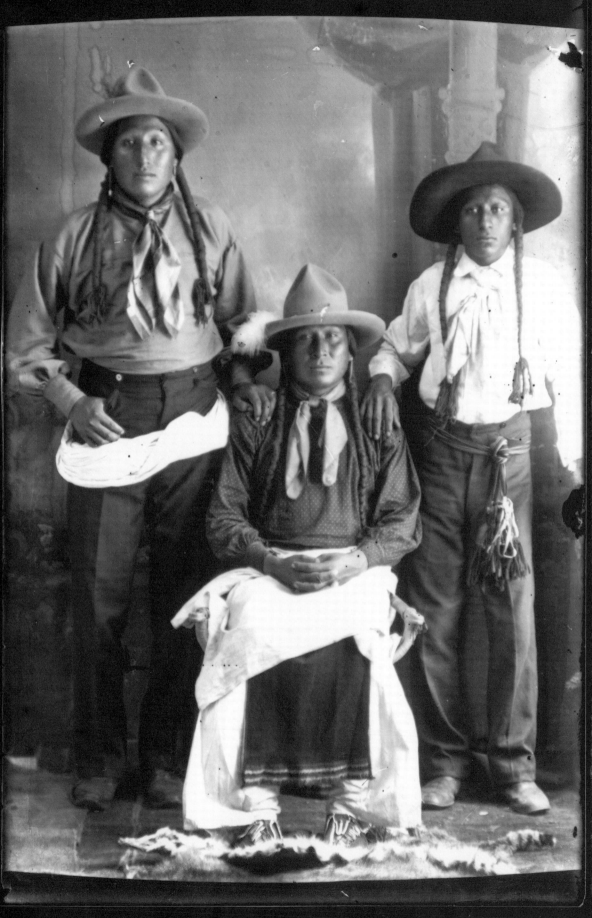

Keithtahroco, Big John Pewewardy, and Pahkumah

The seated Comanche man is Keithtahroco, the son of Chief Horseback. The other men are Big John Pewewardy (*left*) and Pahkumah (*right*), a deaf mute. Margaret Thomas, a Comanche woman, on seeing this photograph recently, remembered these men from her youth. "Pahkumah" means "edge of the water." He was reputed to have curative power, and there is an Indian medicine with the same name.

"Pewewardy" is pronounced "Peewardy." According to this man's daughter Ella, about ten children born to her father and his wife, Poiewheup, are buried in the Otipoby Cemetery at Fort Sill, suggesting—when taken with other instances of multiple childhood deaths—that infant and child mortality rates among Comanches were remarkably high prior to World War II.

Keithtahroco (1875–1919) was also known as "Horseback," although his name includes no recognizable element for "horse." On the other hand, the name of his father, Tirhayaquahip, translates literally as "horse back" (not as "sore-backed horse," as has been suggested). Chief Horseback of the Nokoni division signed the 1867 Medicine Lodge Treaty. About the same year he reluctantly agreed to the ransoming of his brother Pernerney's captive Texan, fifteen-year-old Theodore Adolphus "Dot" Babb, by Esserhaby, another Comanche chief, for several horses, bridles, blankets, saddles, and other goods. Esserhaby later delivered the boy to Fort Arbuckle, southeast of Fort Sill, and presumably was repaid by Babb's father.

The three men wear clothing more or less typical of the everyday dress of the period: cowboy hats (Keithtahroco's with eagle plume), neckerchiefs, trousers without suspenders. Pahkumah wears a knotted sash similar to those worn today by gourd dancers. Horseback and Big John wear light blankets—or might they be sheets?—around their waists. At that time it was customary for Comanche men to cover themselves appropriately when they squatted to relieve themselves.

Tonawer and Pautchee

The seated man is Tonawer, the brother of a wife of Isatai, Tovetty. The other is Pautchee. Isatai was the Comanche chief and prophet largely responsible for the 1874 Battle of Adobe Walls, which in turn precipitated the Red River War of the same year, and led to the final defeat of the Comanches by the U.S. Army. Chiefs Isatai and Quanah Parker led the Kwahada division of the Comanches to their surrender at Fort Sill in June of 1875. Traditionally, the Comanches were horsemen and horsewomen. Both men in the photo wear horsemen's boots, and Pautchee carries a quirt suspended from his left wrist.

Lieutenant Colonel Richard I. Dodge pointed out that Plains Indians of the period scorned fighting with their fists, but instead reached for the nearest knife, club, hatchet, or—like the trail cowboys—gun. In some instances, a quirt might serve against a fellow tribesman as an instrument less likely than any of the above to have fatal consequences. In 1823 when Thomas James was trading with a band of Comanches, a few warriors intimidated his men and retrieved four of the best horses he had gained through barter. On learning of this, his "brother," the One-Eyed Chief, rode off, quirt in hand. That evening, when the war chief returned the fourth horse to James, "his whip was bloody and his face distorted with rage." No more of James's horses were taken.

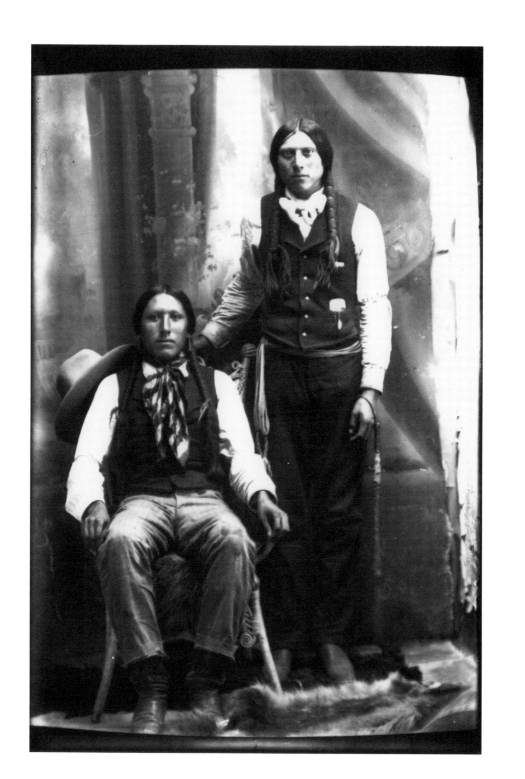

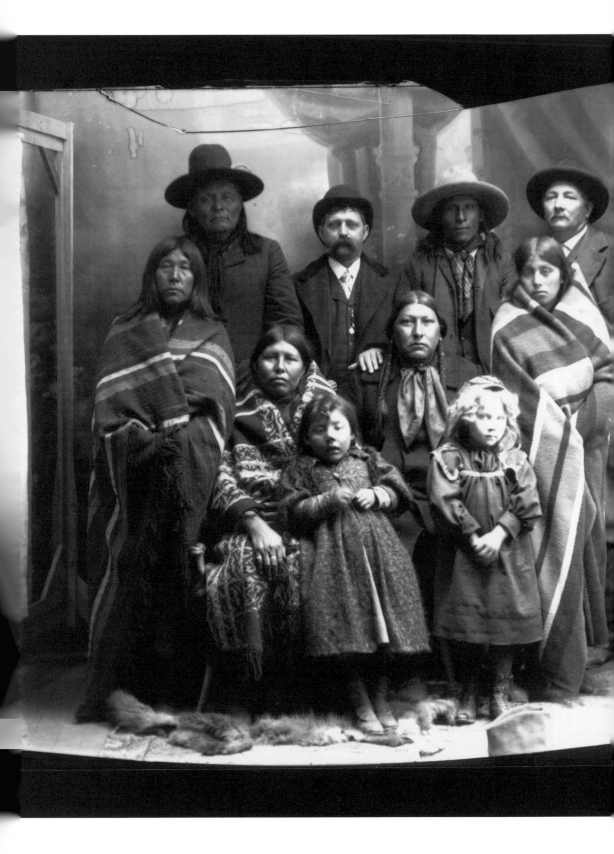

Tissoyo, Yannyconny, Pete Snearly, and Others

The Comanche man wearing a black hat (*back row, far left*) is Quoyah. Immediately to his left is Norman "Pete" Snearly, Alice's uncle, owner of the St. Elmo Hotel in Henrietta, Texas. Next to Snearly is Sovo, with an unidentified white man beside him. The woman standing far left has tentatively been identified as Tahvecha, a wife of Isatai, Comanche chief and prophet. The seated man in the front row with the light on his face and Snearly's hand on his shoulder is Tissoyo, whose Christian name was Jasper. (But Comanches, finding the letter J difficult to pronounce, called him Casper.) The seated woman to his right is Yannyconny. These two were brother and sister, son and daughter of Comanche chief Mowway. To Tissoyo's left, wrapped in a blanket, stands Sally Nahsaquz (or Cochay), Sovo's wife. The little girl leaning back against Yannyconny is Helen Quoyah, daughter of Quoyah and Yannyconny. The other child remains unidentified.

Yannyconny

The woman shown here, named Yannyconny, was the daughter of the celebrated Comanche chief Mowway, of the Kotsoteka division of the tribe. Note the amount of netting in the fringe of Yannyconny's shawl, which is worn over her shoulders in the manner prescribed for women powwow dancers today. Her brother Tissoyo, portrayed in Photo 5, once told of how their father rescued a companion attacked by a grizzly bear, killing the animal with his knife. Afterward he wore a great claw of the grizzly in his scalp lock. (Mowway's name, according to his son, meant "Push Aside.") The Kotsoteka chief, like Horseback, signed the 1867 Medicine Lodge Treaty. He died of pneumonia on his family farm in 1886.

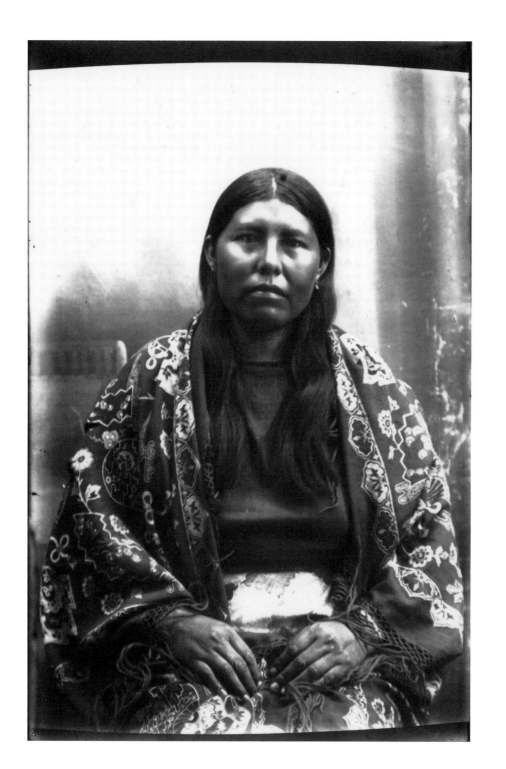

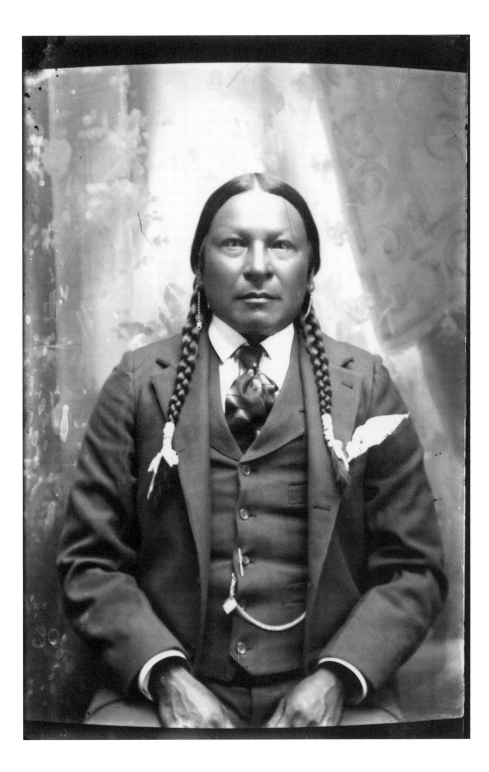

Frank Moetah

This print portrays Frank Moetah, the second husband of Yannyconny, shown in Photo 6. He married her after Quoyah's death. Moetah was a leader of an anti-Quanah faction among the Comanches, and because of that, the object of Indian Agent Frank Baldwin's wrath on at least one occasion. Still, he was appointed to replace Quanah as a judge on the Court of Indian Offenses in 1898 when Chief Parker was censured for his polygamy. It is interesting to note that this rival to Quanah is wearing a suit and appearing formal, if not "official," in attire that would have surely pleased an Indian agent. Moetah also served, in at least one instance, as an informant for Wallace and Hoebel's *The Comanches: Lords of the South Plains*. Moetah's pendant earrings terminate in a crescent, a design motif that occurs in much German silver, or "peyote," jewelry, and suggests that Frank, like Quanah, may have been a "roadman" and peyote leader.

Bert Seahmer,
Tree Top, and Utah

This group portrait shows a youth, Bert Seahmer, standing to the left. The tall man, standing, is Paaduhhuhyahquetop, known in English as "Tree Top," although his name (*pariihya*, "elk," plus *kwitapi*, "excrement") translates literally as "Elk Droppings." Seated to his right is his daughter, Utah, or Blanche, with his other children. Daniel Gelo speculates that *kwitapi* must have sounded like "kwee-top" to Anglo ears and must then have been altered to "Tree Top," providing a fine example of "how Indian names were corrupted and sanitized at the same time."

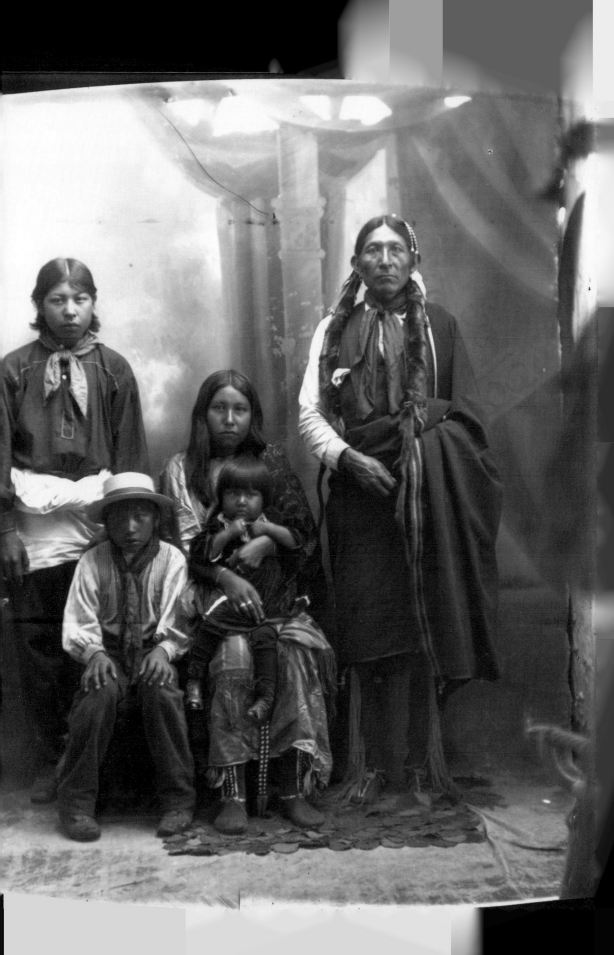

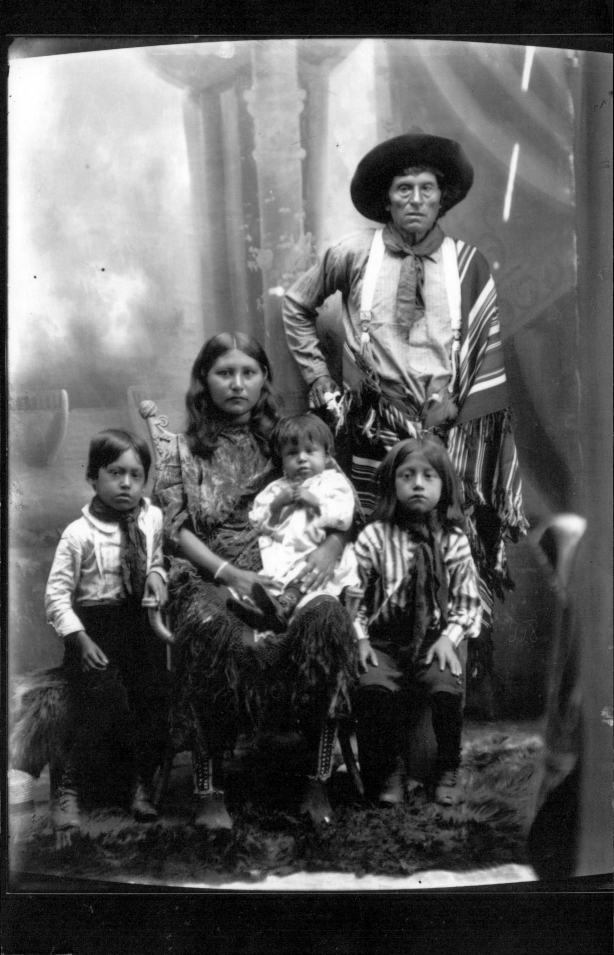

Old Man Komah and Seekadeeah

The subjects of the portrait are Old Man Komah, or Chasuwy, an adopted Mexican captive, and his Comanche wife, Seekadeeah, with their children (*left to right*), Henry, Wilson, and Charley. Appropriately, Komah wears a Mexican blanket over his left shoulder and around his waist. The family rest their feet on a bearskin rug. Wockneahtooah, shown in Photo 10, was also a son of this man. Komah's daughter, Esadooah, appears in Photo 11. During pre-reservation days, Comanche raiders abducted hundreds, perhaps thousands, of captives out of Mexico, almost always women or children.

As early as 1828, Lieutenant Colonel José Francisco Ruíz of the Mexican army estimated that the Comanches held over nine hundred such prisoners. These individuals might become slaves, in which case their lives were extremely hard. Many warriors, however, married captive women (including, later, Anglo-Texans, such as Cynthia Ann Parker, mother of Quanah by Peta Nocona, a Comanche war chief), and many captive children were adopted by childless couples to be raised as Comanches. Komah was doubtless one of these. Part of this strategy was an effort to increase the population of a people constantly depleted by disease and warfare. Other Anglo or Mexican captives might be ransomed for a sufficient amount of trade goods—*if* they could be located by their families of origin.

Wockneahtooah

This Comanche man, Wockneahtooah, or Baby Turtle, also known as Judd Komah, was a son of Old Man Komah, the Mexican captive shown in Photo 9. His mother, however, was almost surely a different woman than the young wife shown with Komah in the previous photograph. Judd Komah's first wife was Edith Tukah-mahkeah, a daughter of Chief Wild Horse. He later married Topay (see Photo 15), former wife of Quanah Parker. In general his attire can be considered highly formal "peyote garb." Like Quanah in Photo 15, Wockneahtooah has wrapped his braids in *papi wïhtamaʔ*, otter or beaver fur strips. The quintessence of a *tuibihtsiʔ*, or young Comanche dandy, he is wearing the usual jewelry and a buckskin shirt fringed at the shoulder, with tailored sleeves and cuffs. The long fringes are characteristically Comanche. His bandolier, worn over the left shoulder, as in the peyote ceremony and the gourd dance today, probably consists of mescal beans or possibly brass beads or a combination of the two.

The red or mescal bean (Texas mountain laurel) is still commonly strung on ceremonial bandoliers and has some symbolic association with peyote and super-natural power, although—being highly toxic—it is not eaten. Wockneahtooah's leggings are decorated with brass tacks. He wears Comanche-style moccasins with metal cone "tinklers" along the instep and beaded rosettes that may match the rosettes on his braids. He holds a fan consisting (probably) of tail feathers from an immature golden eagle, surrounded by eagle down and feathers from a small bird, perhaps a scissor-tailed flycatcher. There is an eagle plume on his right shoulder, another feather placed in his hair, and a second fan at his feet.

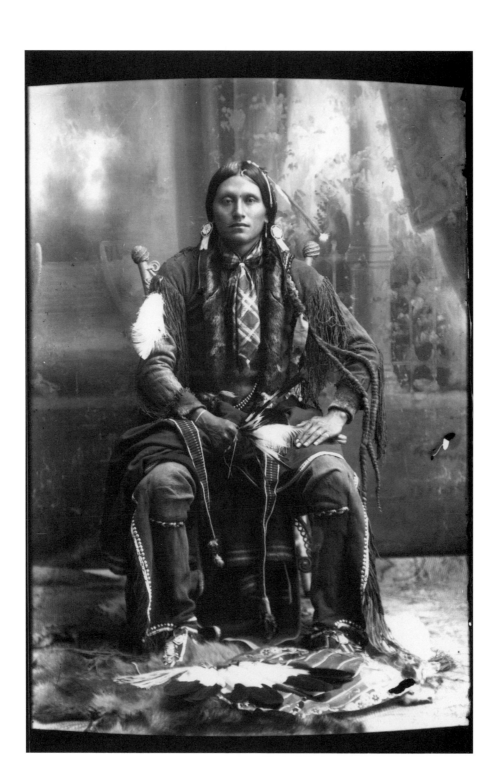

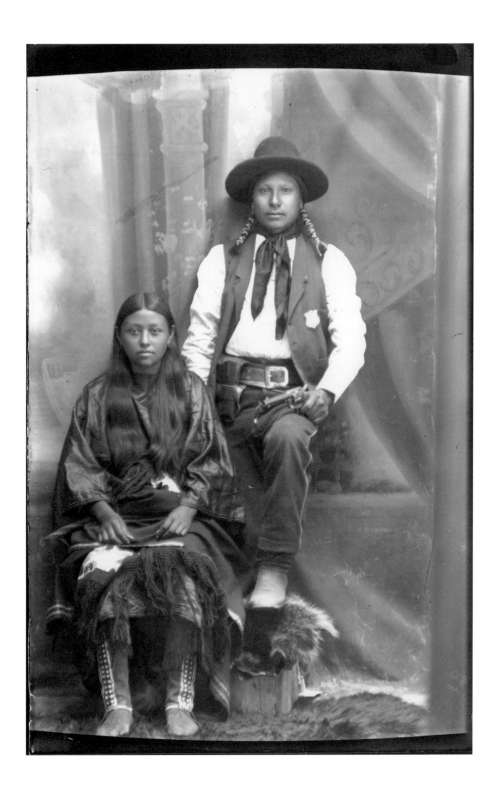

Esadooah with Knox Tockawunna, Policeman

The seated woman is Esadooah, a daughter of Komah. The policeman is Knox Tockawunna. Presumably Esadooah ("Wolf Cub," from *isa*, "wolf," and *tua*, "son" or "offspring") and Wockneahtooah are siblings, or half- or stepsiblings. Tockawunna holds his revolver and regards the camera with what appears to be serene self-confidence. It is interesting to contrast his natural pose and relaxed demeanor with that of a "costumed" Geronimo dramatically gripping a revolver in Photo 17. The present photograph is attributed to Alice Snearly, while that of Geronimo was taken by George Long.

The Indian police force was inaugurated in 1878 but was so poorly funded in the beginning that for the first two years its members were compelled to borrow weapons from the army. In 1880 they were issued rifles. Side arms apparently came later. The Indian police helped to diminish the influx of horse thieves, mostly crossing the Red River from Texas. Until the Indian agent approved grazing leases to the Texas cattlemen, the police force was also active in herding unauthorized cattle off the reservation. The Comanche word for an Indian policeman, incidentally, was *toi-tah-ner-eu*, meaning literally, "tie-up Indian."

Mounted Comanche Girl

Here, a shy-looking Comanche girl sits astride her paint horse before a wagon, with other horses and wagons in the background. Margaret Thomas, an elderly Comanche woman, remarked when she saw this photo that in her youth, "just about everybody had a wagon like this. People sat facing each other on two long seats along the back." Comanche girls were often superb riders. In 1852 Captain Randolph Marcy found many Comanche women "equally as expert, as equestrians, with the men." He reported, as an example, observing two young women, mounted on swift horses, overtake a herd of antelope. Each girl, like an expert rodeo cowboy, roped one of the animals and triumphantly led it back to the Comanche camp. In pre-reservation days, incidentally, some Comanche women may have maintained antelopes as pets, as suggested by a "Comanche collar for a pet antelope" collected in Texas around 1828 by the French botanist, Jean Louis Berlandier.

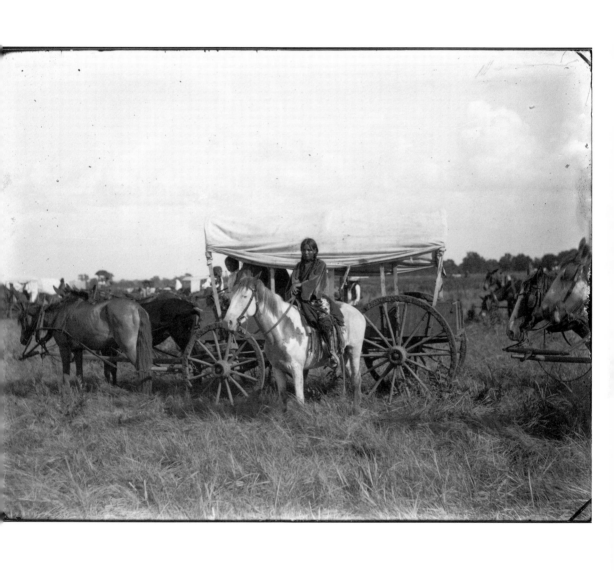

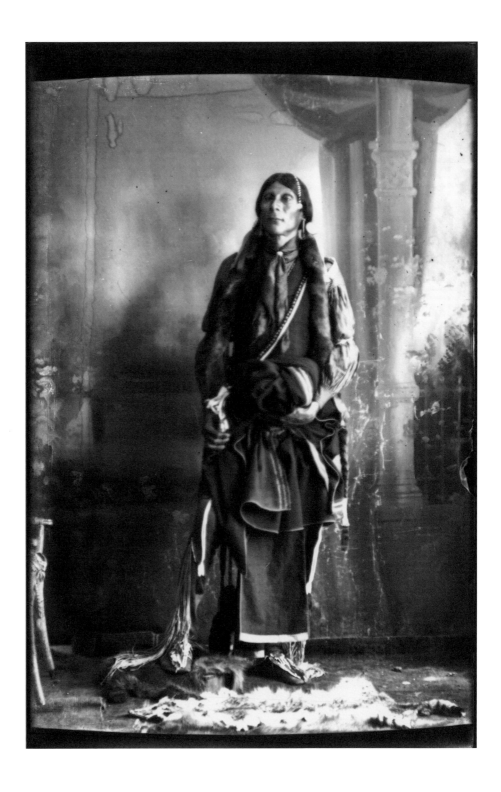

Muvecotchy

Muvecotchy, also Comanche, was evidently yet another devotee of peyote ceremonies. His clothing is similar to the formal peyote garb worn by Wockneahtooah and Quanah in Photos 10 and 15. His bandolier consists of paired strands of mescal beans and metal beads. It is interesting to note that Muvecotchy, in the proud dignity of his pose before the painted canvas backdrop, suggests an actor from classical tragedy, drawn perhaps from a drama by Sophocles or Racine. This is not inappropriate, given the post-contact history of the Comanches, along with that of most other American Indian tribes.

Sherman Poco

This portrait shows a Comanche boy, Sherman Poco, in elaborate dress. He may have been a son of Marcus Poco, who was a Carlisle alumnus, an agency policeman, and a prominent early peyotist who transported cactus buttons from Mexico for Quanah. He wears a short breastplate of halved hairpipes (fabricated especially for children). Hairpipes, made from the conch shells used to ballast sailing ships and later from cow bones, were originally manufactured in New Jersey for the Indian trade. Apparently glass tube beads and round brass beads separate the rows of hairpipe. Poco also wears a bandolier of metal beads and a leather pouch of the kind employed for carrying medicinal herbs and pigments. Mescal beads, incidentally, would have been considered too potent with supernatural power for a child to handle or wear.

One wonders about this boy's first name. It would be ironic if he had been named for William Tecumseh Sherman, commander of the U.S. Army from 1869 to 1884. Even so, during the 1830s and 1840s when the Comanches were raiding relentlessly into Mexico, one well-known chief bore the name Santa Anna, identical to that of the Mexican president and general defeated and captured by Sam Houston at the Battle of San Jacinto in 1836. Was this chief a namesake? We can only guess.

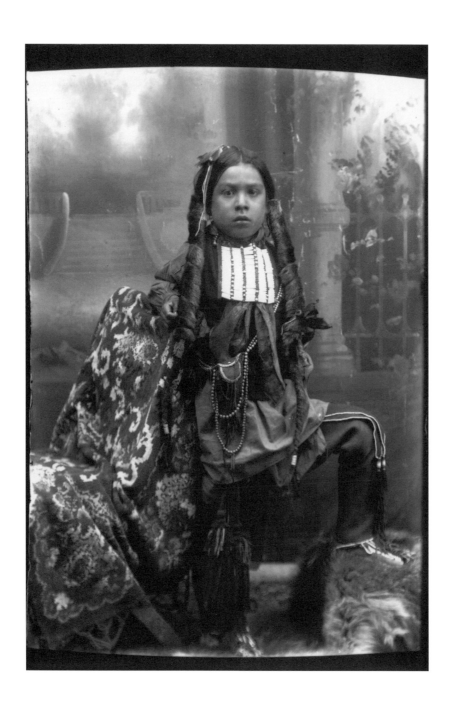

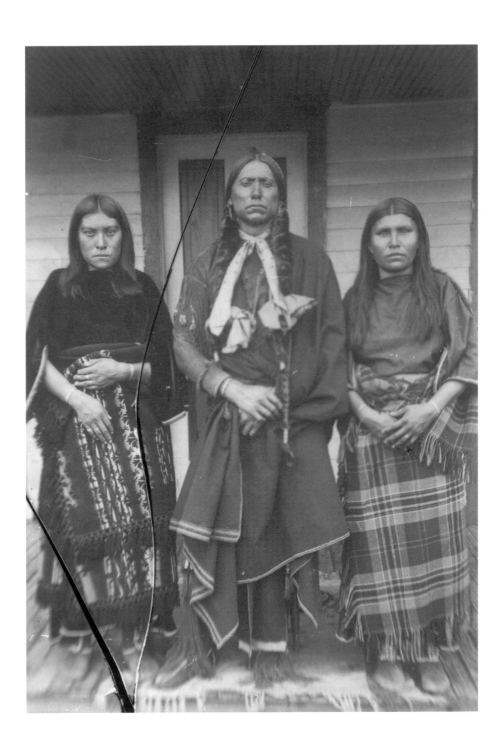

Quanah Parker with Two Wives

Quanah Parker poses with two of his at least seven wives (although he was not married to all of them simultaneously). Topay is on the left and Chonie on the right. Around 1890 Quanah paid Topay's husband, a Comanche named Eckcapta, fifty dollars, and a buggy, team, and harness for her. This payment, though not a "purchase price," represented a traditional compensation for the loss of a wife to another man. In fact, it is possible that Topay herself may have chosen to leave Eckcapta and go to Quanah. Parker added her to his household in spite of the disapproval of the Indian commissioner, an act that cost him his seat on the Court of Indian Offenses. Later Topay apparently left Quanah and married Wockneahtooah.

Both women wear bracelets and rings and are dressed in trade blankets and in shirts cut from trade cloth in the traditional pattern. It is reasonable to suppose that Parker's blanket is dark blue—or half red, half blue—stroud cloth edged with colored ribbon. Such blankets are worn today on ceremonial occasions. His braids are wrapped in otter fur, while his tightly braided topknot rises from the crown of his head and runs along its left side. He wears an earring or earcuff in his right ear and a bracelet on his right wrist. His shirt appears to be traditional buckskin with fringe at the shoulder. The neckerchief is typical of Southern Plains Indian attire during this period. (Noncracked copies of this photo, taken by Irwin, are in the collections of both the University of Oklahoma and the Panhandle Plains Museum.)

Star House

Star House was Quanah Parker's home near Cache, Oklahoma Territory. The handsome two-thousand-dollar building was constructed in the 1880s at the expense of Samuel "Burk" Burnett and other Texas cattle barons who profited from Quanah's trips to Washington, where he lobbied the secretary of the interior and Congress in favor of continuing their grazing leases on the Kiowa, Comanche, Kiowa-Apache reservation. The house bears eighteen stars on its roofs. Quanah is said to have admired the stars worn by American generals and apparently considered it befitting his importance to have stars painted upon his dwelling.

Star House was long ago moved to Eagle Park, a run-down amusement park outside Cache, where it remains today among other antique buildings, although it was reroofed during the spring of 1996. The viewer may gain an idea of the house's grandeur relative to its time and place by comparing it with the early Texas farmhouse, itself a large and comfortable dwelling, displayed in Photo 27.

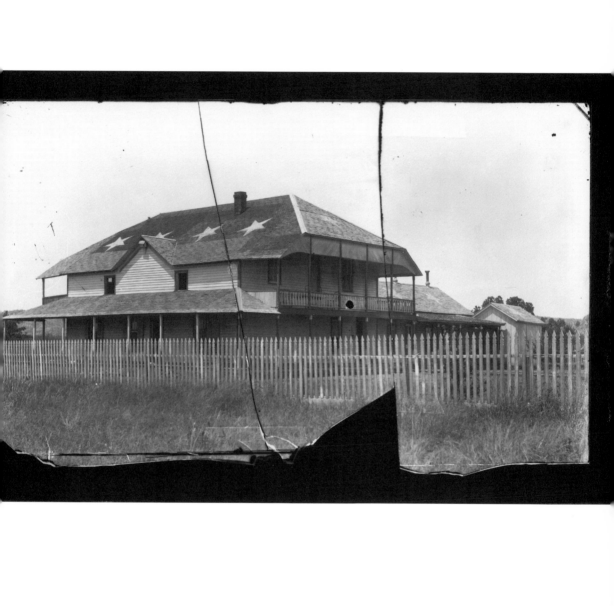

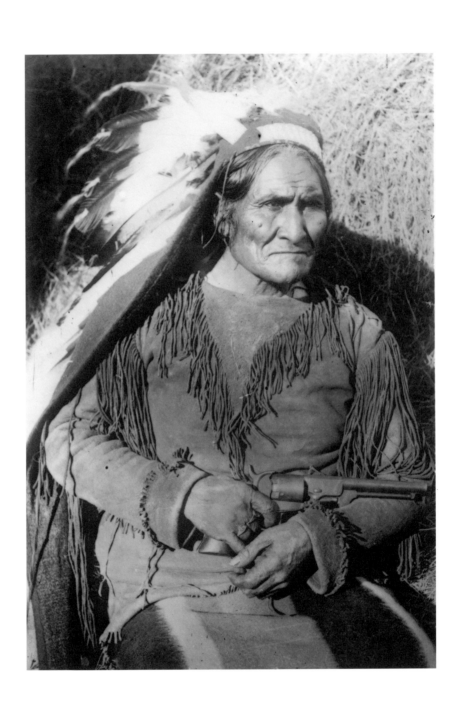

Apache Leader Geronimo, Posing

Geronimo, a Chiricahua Apache leader, was the principal live trophy of one of America's last Indian wars. Officially a prisoner of war at Fort Sill, he was nevertheless featured at public spectacles, such as Pawnee Bill's Wild West Show. The old man learned to write his name and, because of his celebrity, was able to sell his autographed portraits for two dollars apiece—for instance at the 1904 St. Louis World's Fair. One elderly Comanche woman tells of her mother's memory of Geronimo sometimes riding on a trolley (*oha waikina*, "yellow wagon") from the post to Lawton, where he would stroll around town window-shopping. Finally he would join a group of old Indian men seated on the steps of the Warren Hotel, where they would spend an afternoon together. At day's end, he would ride back to Fort Sill, where she understood that he was locked up. Yet contrary to popular belief, Geronimo was not jailed at the post. Occasionally, if he were drunk on his return, soldiers would lock him in the guardhouse; otherwise he was free to go home to his cabin and his family.

Here the photographer's props include a Plains warbonnet and a Dance Brothers revolver, which was a Confederate copy of a Colt. The buckskin shirt with tailored sleeves and cuffs is a late version of the classic Plains war shirt. The Chiricahuas were not, of course, Plains Indians but had inhabited the mountains and deserts of present Arizona. The melodramatic pose is typical of the sort favored by many strictly commercial photographers of Indian subjects. George Long from Mountain View, Kiowa County, Oklahoma Territory, took the original photograph.

Geronimo before Post Oak Arbor

Geronimo, ca. 1898, is seated partly in the shade of a post oak arbor. In spite of his P.O.W. status, he was serving as an American military scout. Along with several other Apache men, he had been enrolled in the U.S. Army and issued a uniform. The purpose of this curious contradiction in roles was to secure the allegiance of Geronimo and the others to the U.S. government. The stratagem was successful, as indicated in the caption for Photo 2.

Another photo from the same period (not included here) shows Geronimo similarly dressed and standing on a farm near Fort Sill with his wife, Ziyeh, and three children. There, he is holding a large melon or pumpkin. His expression is not that of a contented Christian farmer. At heart Geronimo remained a warrior. Even as an old man the Apache chieftain took pride in the skills and scars of his former vocation.

Around 1905 he bested an Anglo artist—who had come to paint his portrait—in marksmanship with the man's own .22 rifle, perforating a distant scrap of paper, while the painter missed on each attempt. On another occasion he removed his shirt and, according to the dazzled artist, displayed the scars of "at least fifty bullet wounds." For the painter's benefit, he would push a pebble into a bullet scar. Making the explosive sound of a gunshot, he would pluck it out and hurl it to the earth, boasting afterward that no bullet could kill him.

Fate allowed him to retain this illusion. Geronimo's end came in the winter of 1909 when he was eighty-five. Having ridden his horse to Lawton to sell toy bows and arrows he had made, he embarked on a drinking binge with the sale money. On his way home he fell from his horse and lay on the ground throughout the night. The old warrior contracted pneumonia and died several days later. His tombstone at Fort Sill remains an attraction for visitors.

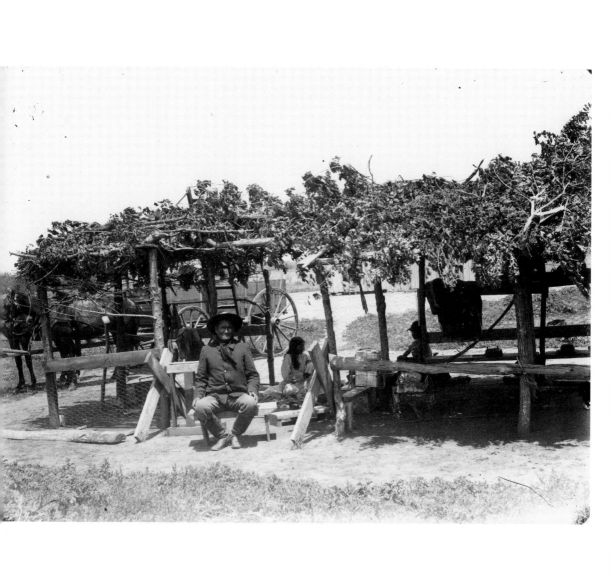

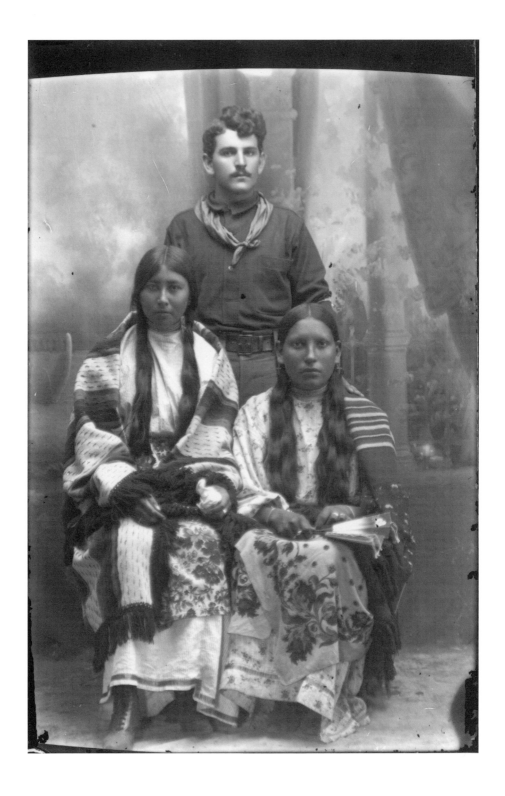

Curly "Bud" Ballew with Amy and Carrie

Curly "Bud" Ballew poses with Amy Bear, wife of Bert Bear, and with Carrie, daughter of Iseeo and wife of White Fox. Both women were Kiowas, members of a tribe that had been allied with the Comanches since at least 1806, and now shared the reservation with them and the Kiowa-Apaches. Amy's husband, Bert, was employed as a clerk at the well-known Red Store, a trading house dating from 1886 and constructed from lumber hauled from Henrietta, Texas. The store was situated several miles south of Fort Sill.

Carrie's father, Iseeo, a former army scout, was first sergeant of Troop L, Seventh Cavalry, composed mostly of Kiowas, along with a few Apaches and Comanches, and commanded by Lieutenant Hugh L. Scott. The troop, stationed at Fort Sill, performed its duties effectively until 1897, when the War Department disbanded all Indian units. In 1915 Iseeo, reduced to poverty, caught the attention of his former commanding officer, Hugh Scott, then a major general and chief of staff of the U.S. Army. Scott arranged for the old man to hold the rank of senior duty sergeant for the rest of his life, his single duty being to draw his monthly pay. He lived until 1927.

Bud Ballew was a deputy sheriff from Ardmore, Oklahoma, serving under Carter County Sheriff Buck Garrett from around 1911 until 1922. He died in a Wichita Falls saloon shoot-out in 1924. Texas Ranger J. W. McCormick had forbidden the Oklahoman to visit Wichita Falls wearing his sidearm. Ballew disregarded the warning. When the ranger encountered him, Ballew snatched at his revolver, but McCormick beat him to the draw and killed him.

Both women wear Mexican serapes, still popular today among Comanches as gifts. The pale clothing and floral patterns differ from the colors and shapes found in most of the Comanche women's attire, perhaps indicating a cultural preference, since floral patterns are particularly common in Kiowa beadwork. Note that Amy wears high-laced store-bought shoes rather than moccasins and wears a ring on her left hand. Carrie wears cross earrings, rings on her fingers, and (probably) copper bracelets. She holds a feather fan made from the trimmed tail feathers of a rough-legged hawk or an immature golden eagle.

Cache Issue Station, Oklahoma Territory

Comanche horsemen are gathered before the Cache issue station, which they called Pesenahdumun, or "the place of putrid meat." The Comanche name derives from the word for "pus" or "infected" or "festering" joined with the word for "store," and, by extension, "town." Meat was issued at this station before refrigeration was common, and doubtless some of it was spoiled when distributed. Here the Comanche men were probably awaiting the regular issuance of government rations, a practice that continued until 1901, and—in a greatly reduced fashion—beyond. The town of Cache is named for nearby Cache Creek, the source of "Cache" being the French word *cacher*, meaning "to hide." George R. Stewart notes in *Names on the Land* that "the many streams called Cache Creek recorded a place where furs and trade goods were carefully buried to await their owners' return."

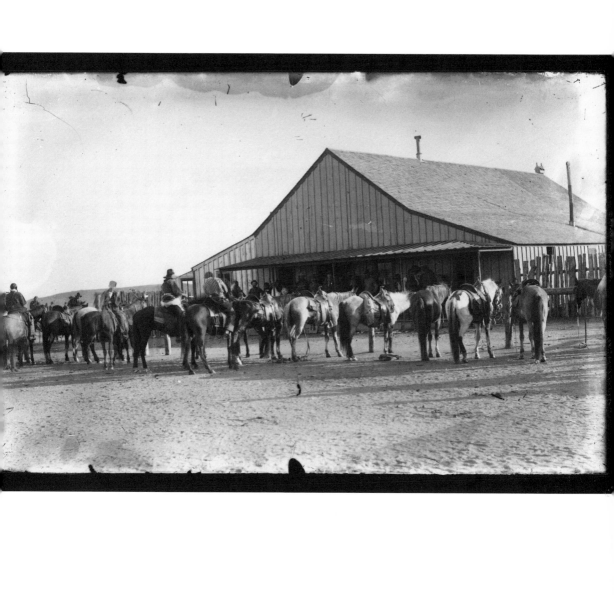

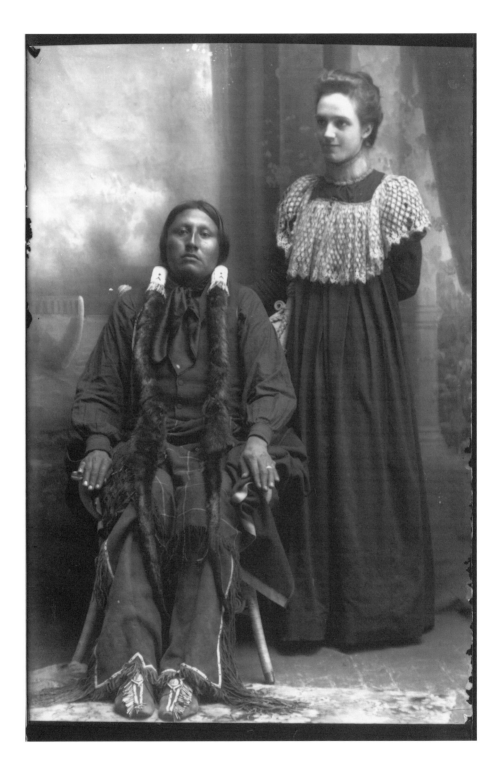

Piah Kiowa Posing with Gertrude Kelley

Again the Comanche man with the misleading name poses. This time he sits uncomfortably, as if in a dentist's chair, with Gertrude, Alice's sister and Lon Kelley's wife, standing behind him. Could it be that Mrs. Kelley was a stranger to him? In this plate he wears, instead of horseman's boots, what the Comanches call "peyote shoes"—moccasins with medallions representing peyote buttons.

General Store

This plate provides a view of the interior of a general store of the period, location uncertain, complete with wood stove and linoleum floor. However, since the Kelleys were part-owners of a store in Henrietta, the photograph may well depict their place of business. It is tended by two clerks, one of whom wears that badge of gentility, a necktie. Note the packages of seeds to the left and what appear to be dolls in the glass showcase to the right, as well as a toy coach with toy horses on the counter. Also to the right on the floor is what appears to be an ancestor of the modern shopping cart. The photographer evidently used a hand-held trough of magnesium flash powder, as indicated by the bright reflection on the ceiling, to the left rear of the room, below and behind a kerosene lamp.

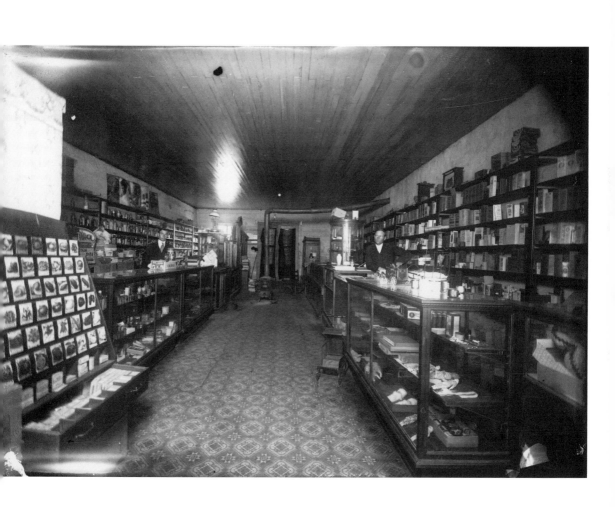

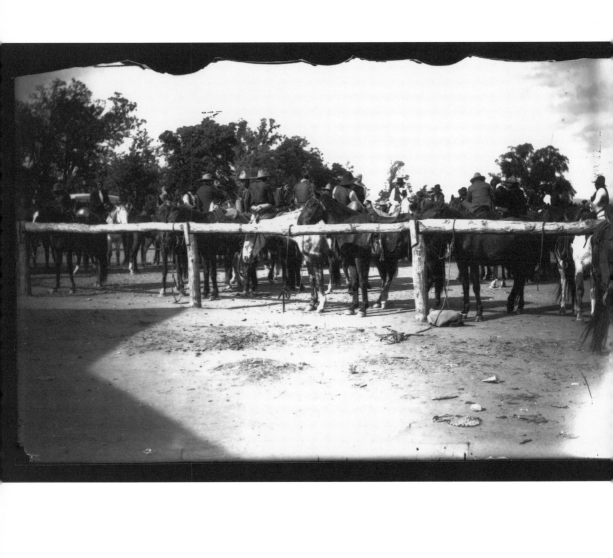

Hitching Rack before the Issue Station

This photograph shows horses and men, some of them Indians, before and beyond a hitching rack, again at the Cache issue station. Note that the horses here are full-sized "American" horses. Although there is one pinto, a piebald combination favored by the Plains Indians, none is an "Indian pony." Such ponies, of mustang stock and perfectly adapted to the Plains, were, by Richard Irving Dodge's account, barely fourteen hands high, slightly built, although with "powerful forequarters, good legs, short strong back and full barrel." These animals bore no resemblance to purebred stock, but their "sharp nervous ears and bright vicious eyes," in Dodge's opinion, indicated "unusual intelligence." Furthermore, their capacity for work and the distances they could travel while subsisting only on grass made them equal—or superior, in this respect—to any breed of horses. Their warrior riders, in the heyday of Comanche power on the Plains, were among the finest horsemen that history has recorded. In addition to being superb equestrians, these men also practiced selective breeding, castrating most of their stallion colts.

Wichita Grass House

A blurred figure stands at the base of this Wichita grass house. Historically, the Wichita peoples were trading partners—and often allies—of the Comanches. The arbor to the left is vaguely similar to a Comanche arbor (*hïïki?aitï*), although there are significant differences. This one, for example, is constructed of prairie grass (technically, little blue stem, even if reddish in color) rather than of the leafy branches Comanches would have used. The Wichita arbors were roundish and dome-shaped, with the saplings supporting the roof curved inward, somewhat like a flattened house with open sides. Margaret Thomas, a Comanche woman whose deceased husband, Paul, a Wichita, had been born in such a dwelling, explained that the Wichita women built their houses out of what the Comanches call "red grass" (*ekasonip*). The Wichita arbors were probably constructed of bunches of the same reddish grass.

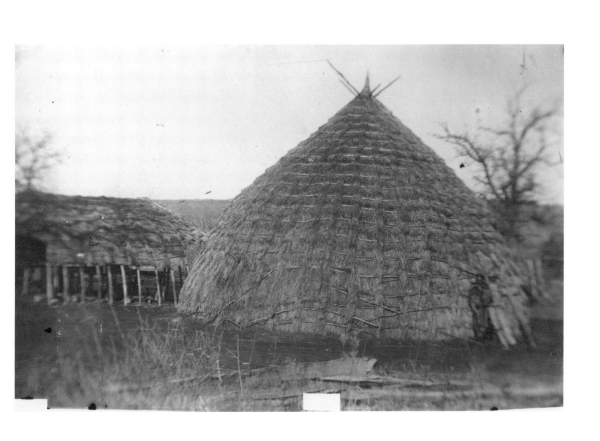

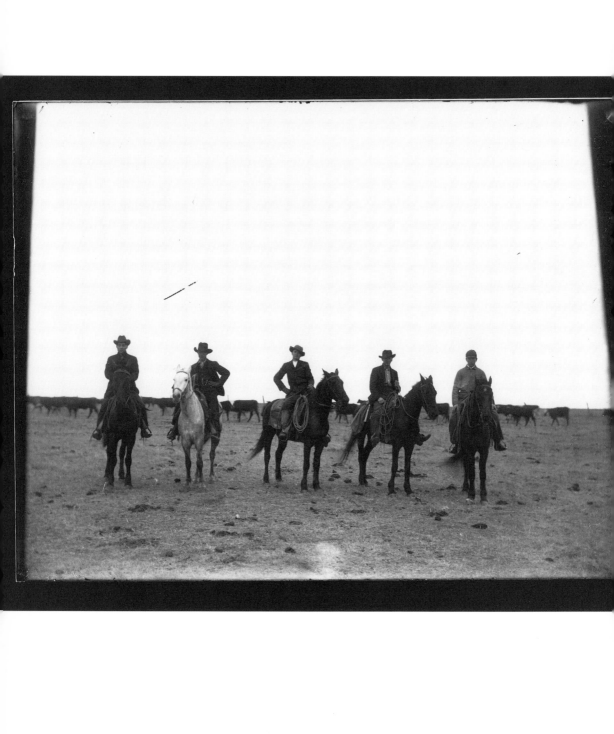

Cowboys with Whiteface Cattle

The photograph depicts five mounted cowhands, evidently within a fenced pasture, who were probably dressed (except for the youth on the far right) to have their pictures taken. What appear to be Hereford (Whiteface) cattle are in the background. Herefords were introduced by William Sude Ikard into Clay County, Texas, in 1876. By a little over a decade later, Ikard and his brother had begun raising registered Herefords. Charles Goodnight, who, like Ikard, began with Durham cattle, brought Whiteface stock into the Texas Panhandle in 1883. By 1900, Hereford cattle had become common in Texas, but William S. Ikard of Clay County was primarily responsible for first establishing this breed in the state.

Gathering of Comanche Men
near Cache

Here the camera records a gathering of Comanche men with their wagons near Cache, Oklahoma Territory. There is an Indian policeman, wearing his badge, in the picture and a view of the Wichita Mountains in the background. The policeman has been identified as Connavichnah. (The "U.S." on the Indian Police badge resembled the symbol for the American dollar—$.) The photo may depict beef ration day at the Fort Sill Agency. Or the purpose of this gathering may have been to enable family heads and others to collect their shares of the "grass money" Texas cattlemen paid for leasing reservation lands. These funds made it possible for Comanches to purchase wagons such as those seen in this picture. With the money they might also build frame houses, similar in construction to, although far more modest than, the early Texas farmhouse displayed in Photo 27.

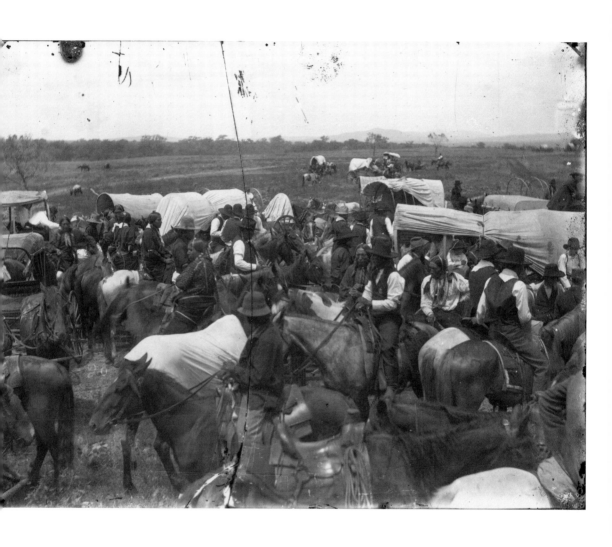

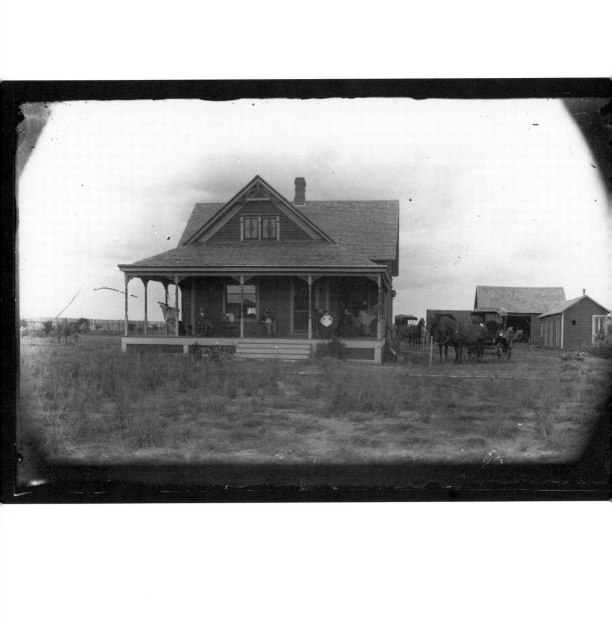

Early Texas Farmhouse

The photo depicts an early Clay County, Texas, farmhouse, with what seems to be a prosperous Anglo extended family comfortably (for the most part) seated on its veranda in hammocks and rocking chairs. A comparison of this building with Quanah Parker's Star House reveals the dwelling that Burnett and other cattle barons built for the "last Comanche chief" to be a mansion.

In this instance, notice the milk cow tethered in the background to the left, indicating no lack of milk, butter, and cheese in the household. This family appeared to take as much pride in its horses and carriages as prosperous Texas farmers and ranchers do today in their Cadillacs and their deluxe pickups and horse trailers.

Parade Forming on Henrietta Square

The photo records what appears to be a parade, consisting mostly of Comanche Indians, forming on the square in Henrietta, Texas. Fort Sill Indians frequently visited Henrietta around 1900, when Alice Snearly took this photograph. The white man at the head of the procession is Harrison Schwend, who served from the early 1880s as Constable and Special Officer of the penitentiary, and later as Henrietta City Marshall and Deputy Sheriff of Clay County. Schwend enjoyed a reputation for fearlessness, fairness, and honesty and is said to have been trusted by the Indians of Oklahoma Territory.

Note the horizontal stripes painted on the shoulders of the horse behind Schwend's, and the little boy mounted on a pony and wearing a warbonnet. Indian parades in towns of the upper Red River region were a convenient locale for interaction between Native Americans and Anglos, situations in which mutual good will might be expressed. Quanah Parker was particularly in demand as a participant, and he evidently enjoyed such processions. Parades continue to be important to Indian traditionalists and to chambers of commerce in such towns as Lawton and Anadarko, and some Comanche men today maintain horses, if they can afford to, in order to ride in them.

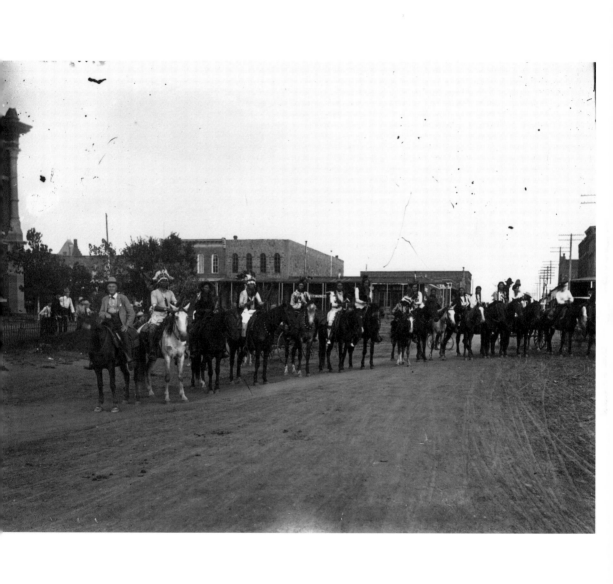

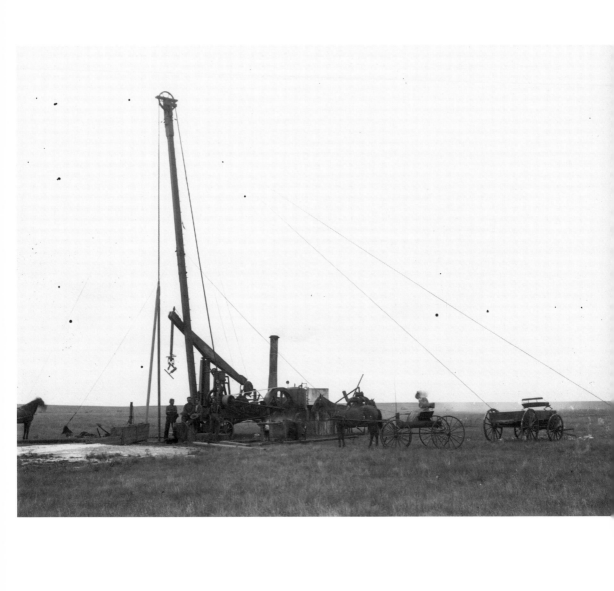

Steam Oil Rig in Petrolia

Here four men stand before a steam oil rig. This oil-field scene, in Petrolia, Texas, 1901, includes an interesting detail: a woman waiting in an American buggy (a light, four-wheeled vehicle with a single seat and no top) behind a harnessed horse on what appears to have been a windy day. Oil was discovered on the Lockridge farm in northern Clay County, Texas, that year. Petrolia, founded about the same time, was first called Oil City. In 1904 it shifted two miles north to take advantage of the arrival of the Wichita Falls and Oklahoma Railroad. The Petrolia Oil Field opened the same year, soon becoming more valuable for natural gas than for oil. By 1913 its gas wells provided a source of power for Dallas, Fort Worth, and twenty-one other northern Texas communities.

Demonstration of a
Kerosene Lamp

The photographer captures a group scene in which a youth exhibits a kerosene lamp to a number of apparently fascinated men gathered along the side of the old Fort Sill cavalry barracks, Oklahoma Territory, ca. 1901. In the audience are several cavalry troopers, who can be identified by their kepis with crossed-saber insignias. The bare-headed Indian standing fifth from left in the background, and wearing a white neckerchief, is Potiyee, a Kiowa man who resembled Quanah Parker. The Comanche man in the center background, just in front of the center wagon, wearing a black hat and neckerchief and white shirt and standing with his head tipped back, is Post Oak Jim, a principal informant for E. Adamson Hoebel while that anthropologist was taking notes for the classic *The Comanches: Lords of the South Plains* (written with Ernest Wallace, 1952). Standing immediately to his left, in a white hat, is George Mopope, Kiowa, father of Steve Mopope, who became a well-known artist. The Indian woman standing before Mopope, holding a child in a cradleboard, is a Fort Sill (or Chiricahua) Apache, as opposed to a member of the Kiowa-Apache tribe (now the Apache Tribe of Oklahoma), who used a lattice cradle like the Kiowas and Comanches.

A former Fort Sill Museum director, Gillette Griswold, opined around 1961 that the occasion may have been a gathering of homesteaders coming to register at the post in July 1901, when the Kiowa, Comanche, Kiowa-Apache reservation was opened to settlement. He believed that the youth in "circus tights" may have been "summoning the crowd to a medicine show," or simply demonstrating the kerosene lamp. The latter explanation is the simpler and perhaps the more likely.

The novelty of what was, during this period, "modern lighting" is illustrated by an earlier incident in 1885 involving Quanah Parker and his uncle (by marriage) Yellow Bear. On a visit together to Fort Worth, where Quanah was often a guest of big cattlemen such as Burk Burnett, E. C. Suggs, and W. T. Waggoner, the two men checked into the Pickwick, the town's most modern hotel. Yellow Bear went to bed while Quanah went off with W. T. Waggoner's foreman, George W. Briggs, whose task it was to entertain the two Comanche men. On his return, Quanah apparently failed to turn off a gas lamp entirely. Yellow Bear died of asphyxiation, while Parker only just survived.

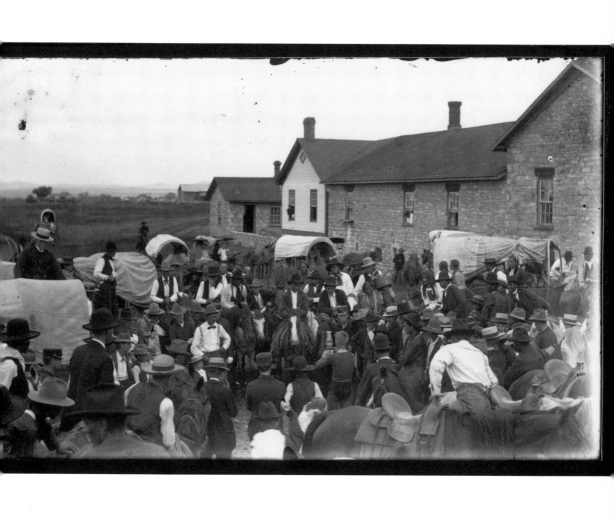

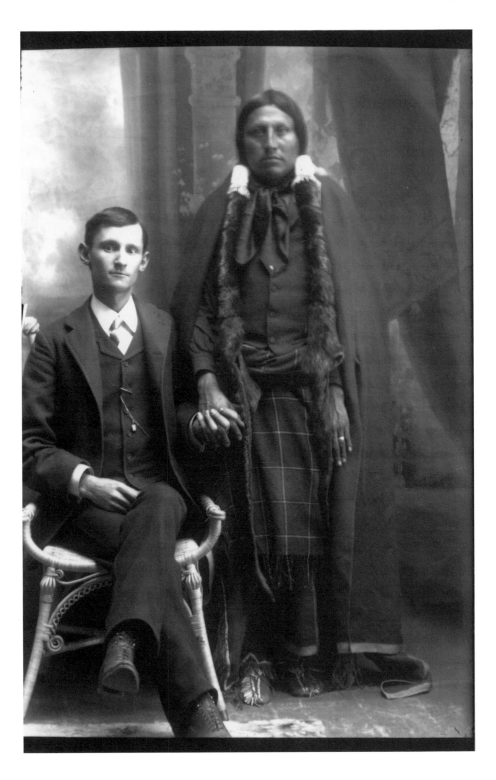

Piah Kiowa with Lon Kelley

Here once more is Piah Kiowa, Comanche, this time with Lon Kelley, Alice's employer, or business partner, and former photography instructor. After Lon, Gertrude, and Alice had returned from their venture in Duncan, Oklahoma, across the Red River, Kelley opened another photography studio in his home town, Henrietta, Texas, on the ground floor of the old jail, which had been replaced around the turn of the century. In addition, he assisted his brothers-in-law at Kelley, Conn, and Snearly's General Store, later serving as Clay County clerk for some fifteen years.

This image of two men holding hands would seem to indicate personal friendship. But we may wonder whether it might not also have been intended to convey more—such as mutual respect and friendship between two peoples, who, not so long before, had been implacable enemies and were now, at last, at peace with each other.

Bibliography

Abbott, E. C. ("Teddy Blue"), and Helena Huntington Smith. *We Pointed Them North: Recollections of a Cowpuncher*. New York: Farrar & Rinehart, 1939. Reprint, rev. ed., Norman: University of Oklahoma Press, 1955.

Adams, Andy. *The Log of a Cowboy: A Narrative of the Old Trail Days*. Boston: Houghton Mifflin, 1903. Reprint, Lincoln: University of Nebraska Press, A Bison Book, 1964.

Berlandier, Jean Louis. *The Indians of Texas in 1830*. Ed. John C. Ewers. Washington, D.C.: Smithsonian Institution Press, 1969.

Boxer, Sarah. "American Indians, Posing and Not." Photography review of *Partial Recall: Photographs of Native North Americans*, at the National Museum of the American Indian, May–July 21, 1996. *New York Times*, Living Arts Section, May 27, 1996, 13.

Burnet, David G. "David G. Burnet's Letters Describing the Comanche Indians." Introduction by Ernest Wallace. In *West Texas Historical Association Yearbook* 30(1954): 115–140. (First published in *Cincinnati Literary Gazette*, 1824.)

Cook, John, R. *The Border and the Buffalo: An Untold Story of the Southwest Plains*. Topeka, Kans.: Crane & Co., 1907. Reprint, Austin: State House Press, 1989.

Curtis, Edward S. *Portraits from North American Indian Life*. New York: Promontory Press, 1972.

———. "The Oklahoma Indians: Peyote Experiences." In *Selected Writings of Edward S. Curtis: Excerpts from Vols. 1–20 of The North American Indian*, ed. Barry Gifford. Berkeley: Creative Arts Book Co., 1976.

Dodge, Richard Irving. *Our Wild Indians*. 1882. Reprint, Freeport, N.Y.: Books for Libraries Press, 1970.

Everson, William K. *A Pictorial History of the Western Film*. Secaucus, N.J.: The Citadel Press, 1969.

Farr, William E. *The Reservation Blackfeet, 1882–1945: A Photographic History of Cultural Survival*. Seattle: University of Washington Press, 1984.

Flores, Dan L. "Bison Ecology and Bison Diplomacy: The Southern Plains from 1800 to 1850." *Journal of American History* 78(Sept. 1991): 465–485.

Foster, Morris W. *Being Comanche: A Social History of an American Indian Community*. Tucson: The University of Arizona Press, 1991.

García Rejón, Manuel, comp. *Comanche Vocabulary: Trilingual Edition*. Trans. and ed. Daniel J. Gelo. Austin: University of Texas Press, 1995.

Gelo, Daniel. "Comanche Belief and Ritual." Ph.D. diss., Rutgers University, 1986.

Goodin, Barbara, ed. "Centennial: Otipoby Comanche Cemetery, 1888–1988." N.p., n.d.

Gregg, Josiah. *Commerce of the Prairies: The Journal of a Santa Fe Trader.* 1844. Reprint, Dallas: Southwest Press, 1933.

Gunnerson, Dolores. *The Jicarilla Apaches: A Study in Survival.* DeKalb: Northern Illinois University Press, 1974.

Hagan, William T. *United States–Comanche Relations: The Reservation Years.* New Haven: Yale University Press, 1976. Rev. ed., Norman: University of Oklahoma Press, 1990.

———. *Quanah Parker, Comanche Chief.* The Oklahoma Western Biographies. Norman: University of Oklahoma Press, 1993.

Hathaway, Nancy. *Native American Portraits 1862–1918: Photographs from the Collection of Kurt Koegler.* San Francisco: Chronicle Books, 1990.

Hollon, W. Eugene. *The Southwest Old and New.* New York: Alfred A. Knopf, 1961. Reprint, Lincoln: University of Nebraska Press, A Bison Book, 1968.

Hurn, Eugene W. *Clay County: A Half-Century in Photographs (1873–1922).* N.p., n.d. (P.O. Box 489, Henrietta, TX 76365).

James, Thomas. *Three Years among the Indians and Mexicans.* 1846. Reprint, Chicago: The Lakeside Press, The Lakeside Classics Series, 1953.

Kavanagh, Thomas W. *Comanche Political History: An Ethnohistorical Perspective, 1706–1875.* Studies in the Anthropology of North American Indians. Lincoln: University of Nebraska Press, 1996.

Kelly, Louise, comp. *Wichita County Beginnings.* (Photographs). Burnet, Tex.: Eakin Press, 1982.

Marcy, Randolph B., assisted by George B. McClellan, U.S. Engineers. "Exploration of the Red River of Louisiana in the Year 1852." Senate Document no. 54, 32d Cong., 2d sess. Washington, D.C., 1853.

McHugh, Tom. *The Time of the Buffalo.* Reprint, Lincoln: University of Nebraska Press, A Bison Book, 1972.

Morris, John W., Charles R. Goins, and Edwin C. McReynolds. *Historical Atlas of Oklahoma.* 3d ed. Norman: University of Oklahoma Press, 1986.

Moses, L. G. *Wild West Shows and the Images of American Indians, 1883–1933.* Albuquerque: University of New Mexico Press, 1996.

Neeley, Bill. *Quanah Parker and His People.* Ed. William Odom. Slaton, Tex.: Brazos Press, 1986.

Noyes, Stanley. *Los Comanches: The Horse People, 1751–1845.* Albuquerque: University of New Mexico Press, 1993.

Nye, Wilbur Sturtevant. *Plains Indian Raiders: The Final Phases of Warfare from the Arkansas to the Red River,* with original photographs by William S. Soule. Norman: University of Oklahoma Press, 1968.

———. *Carbine and Lance: The Story of Old Fort Sill.* 1937. 3d ed. Norman: University of Oklahoma Press, 1969.

Pool, William C. *A Historical Atlas of Texas,* with maps by Edward Triggs and Lance Wren. Austin: The Encino Press, 1975.

Roberts, David. *Once They Moved like the Wind: Cochise, Geronimo, and the Apache Wars*. New York: Simon & Schuster, 1993.

Ruíz, José Francisco. "Report on the Indian Tribes of Texas in 1828." Facsimile and translation edited and with an introduction by John C. Ewers. Translated from Spanish by Georgette Dorn. No. 5, Western Americana Series. New Haven: Yale University Library, 1972.

Russell, Charles M. *Good Medicine: Memories of the Real West*. Garden City, N.Y.: Garden City Publishing Co., 1929, 1930.

Sante, Luc. "American Photography's Golden Age." *The New York Review of Books* 43(1996): 62–67.

Smithwick, Noah. *The Evolution of a State; Or, Recollection of Old Texas Days*. Compiled by the author's daughter, Nanna Smithwick Donaldson. Austin: Gammel Book Co., 1900 (facsimile, Austin: Steck Company, n.d.).

Sontag, Susan. *On Photography*. 1977. Reprint, New York: Dell Publishing Co., A Delta Book, 1978.

Stanley, Henry M. *My Early Travels and Adventures in America*. London, 1895. Reprint, Lincoln: University of Nebraska Press, A Bison Book, 1982.

Stewart, George R. *Names on the Land: The Classic Story of American Placenaming*. 4th ed. Reprint, San Francisco: Lexikos, 1967.

Taylor, Charles William. *A History of Clay County*. Austin: The Pemberton Press, 1972. Reprint, Austin: The Jenkins Book Publishing Co., 1974.

Tyler, Ronnie. "Quanah Parker's Narrow Escape." *The Chronicles of Oklahoma*, 46(1963): 182–188.

Vroman, A. C. *See* Webb and Weinstein.

Wallace, Ernest, and E. Adamson Hoebel. *The Comanches: Lords of the South Plains*. Norman: University of Oklahoma Press, 1952.

Webb, Walter Prescott. *The Great Plains*. Boston: Ginn and Company, 1931. Reprint, New York: Grosset and Dunlap, Grosset's Universal Library, n.d.

———, Editor-in-Chief, et al. *The Handbook of Texas*. 2 vols. Austin: The Texas State Historical Association, 1952.

Webb, William, and Robert A. Weinstein. *Dwellers at the Source: Southwestern Indian Photographs of A. C. Vroman, 1895–1904*, 1973. Reprint, Albuquerque: University of New Mexico Press, 1987.

Wheelock, T. B. "Journal of Colonel Dodge's Expedition from Fort Gibson to the Pawnee Pict Village (1834)." *American State Papers, Military Affairs* 5(1934): 373–382.

White, Richard. *"It's Your Misfortune and None of My Own.": A New History of the American West*. Norman: University of Oklahoma Press, 1991.

Wister, Owen. *The Virginian: A Horseman of the Plains*. 1902. Rev. ed., New York: The Macmillan Co., New Pocket Classics, 1930.

Wright, Muriel H. *A Guide to the Indian Tribes of Oklahoma*. The Civilization of the American Indian Series. Norman: University of Oklahoma Press, 1951.